IMAGES of America
CROFTON

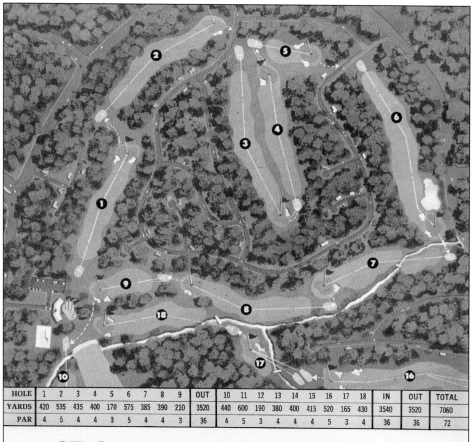

HOLE	1	2	3	4	5	6	7	8	9	OUT	10	11	12	13	14	15	16	17	18	IN	OUT	TOTAL
YARDS	420	535	435	400	170	575	385	390	210	3520	440	600	190	380	400	415	520	165	430	3540	3520	7060
PAR	4	5	4	4	3	5	4	4	3	36	4	5	3	4	4	4	5	3	4	36	36	72

CROFTON
A New Community Built Around a Championship Golf Course

Now your home can overlook one of the most challenging new courses in the Washington-Baltimore-Annapolis area. Crofton's 18-hole championship course will be ready for play in October. But you can see it now. Designed by Edmund B. Ault, this 7,060 yard course will be a pleasure to play. Memberships are being accepted now.

Drive to Crofton, located on Maryland Route 3, three miles north of the U.S. 50 intersection. Show your family the picturesque Crofton Village Green and the Early American shops. See the six Colonial model houses, set in rolling woodland and beautifully furnished by W. & J. Sloane/Mayer.

A private community, built, owned and operated by

CROFTON CORPORATION
division of Crawford Corporation
Crofton, Maryland 21113

Write for details. Residency by invitation only. Year round fun for your family: swimming, tennis, fishing, ice skating, walks in the woods, country club living. **Telephone: (Washington, D.C.) 202-262-8585, (Annapolis, Md.) 301-267-8625, (Baltimore, Md.) 301-974-0980.**

The Crawford Corporation aggressively marketed the planned community of Crofton. Among the selling points was the 210-acre, 18-hole golf course around which the streets were laid out and the first houses nestled. Developer Hamilton Crawford had been building communities in Louisiana for years. This Maryland project would fulfill his dream for a planned community—stately elegance, convenience, and affordability, the best of both urban and rural living. (Courtesy of Joseph L. Browne, Ph.D. [JLB].)

ON THE COVER: For the Walch family, going to market in the 1920s along what is now Route 301 was a different matter than for Crofton residents today. (Courtesy of Julianna Walch Ammon.)

IMAGES of America
CROFTON

Janice Fuhrman Booth

Copyright © 2009 by Janice Fuhrman Booth
ISBN 978-0-7385-6783-9

Published by Arcadia Publishing
Charleston, South Carolina

Printed in the United States of America

Library of Congress Control Number: 2009921907

For all general information contact Arcadia Publishing at:
Telephone 843-853-2070
Fax 843-853-0044
E-mail sales@arcadiapublishing.com
For customer service and orders:
Toll-Free 1-888-313-2665

Visit us on the Internet at www.arcadiapublishing.com

For Crofton and its residents, an old Irish blessing:

Walls for the wind, and a roof for the rain, and chairs beside the fire—
Laughter to cheer you and those you love near you,
And all that your heart may desire!

Contents

Acknowledgments 6

Introduction 7

1. Planting for the Future 9
2. Foundations for the American Dream 29
3. Community Roots 47
4. Nurturing the Community 63
5. Solidifying the Dream: Churches and Schools Cement the Community 83
6. Living the American Dream 95

ACKNOWLEDGMENTS

As with all books of this sort, the author is simply the coach; the finished volume is a team effort. First among equals on this team was Dr. Joseph L. Browne, who generously shared with me the material he had gathered and information he had acquired. His book, *From Sotweed to Suburbia: A History of the Crofton, Maryland, Area: 1660s–1960s*, under the sponsorship of the Rotary Club of Crofton, remains the definitive history of the area. I am grateful, as well, to Juliana Walch Ammon, whose enthusiastic involvement in gathering the photographs and editing the book has been invaluable. Artist and Crofton native Carolyn Finelli has my gratitude for her artistic vision and invaluable Crofton contacts and memories. Mildred Bottner Anderson, Mary Kay Honeycutt, and the members of Pen Women, Anne Arundel Branch, encouraged me during the project; thank you. Katherine Callahan in her leadership roles with the Crofton Garden Club and the Linthicum Walks Historical Society has been a resource for wonderful photographs; thanks to her and the organizations she represents. Thanks, too, to Sue Bents and the Crofton Town Hall archives for their contributions. Finally, I want to express my gratitude to my husband, Larry; my son, Aaron Booth; and my friends for their encouragement and patience during this project.

INTRODUCTION

This book about Crofton, Maryland, is a compendium of dreams—the dreams of the original settlers of the land in the 1660s, the dreams of the European immigrants to the region in the 1920s, and the dreams of W. Hamilton Crawford and the wave of suburbanites he attracted to Crofton in the 1960s and early 1970s. The photographs in this book capture some of those dreams in images of work and play, worship and ownership.

While historians and urban planners may study the population growth, economic conditions, and stability of Crawford's great planned-community experiment, Images of America: *Crofton* studies the simple triumphs and pleasures of life in a small town.

Crofton is situated east of the nation's capital, Washington, D.C., and west of the state capital, Annapolis, Maryland. Crofton's developer, W. Hamilton Crawford, dreamed of erecting an idyllic place to live. He took inspiration from Williamsburg, Virginia, perhaps the earliest planned community in North America. Seventeenth-century Williamsburg, like Philadelphia, Washington, and Annapolis, was planned prior to construction rather than evolving as need arose. Several 20th-century movements arose to reintroduce planned communities into the American landscape.

Established in 1964, Crofton was Hamilton Crawford's idealized lifestyle for middle-class families. Everything from roads and shopping areas to churches and schools was carefully designed and laid out in a master plan. The Village Green shops, offices, and townhouses were distinctly Colonial in style. The First Baptist Church of Crofton was built to resemble Williamsburg's c. 1660 Bruton Anglican Parish Church. The homes surround a palatial golf course, with greens abutting to backyards in cozy ease.

Building on Crawford's dream, what the photographs in this volume capture are the dreams of residents who became homeowners and invested their lives in Crofton. Their dreams are in the eyes, the poses, the homes, and activities captured by box cameras and Polaroids. Some of the photographs included here were snapped more than a century ago by wandering photographers.

Images of America: *Crofton* is a simple history woven from the Yuletide hanging-of-the-greens, Independence Day parades and fairs, Easter bonnet contests, bicycle races and pumpkin design competitions, the softball and soccer and basketball teams, and the summer concerts on the Green. Those pictures show us history as it was lived.

The images in this volume come from albums, boxes, and drawers of current and former residents of Crofton, along with photographs from the Ann Arrundell County Historical Society's Kuethe Library collection. That collection and this book were expanded by the donation of photographs collected by Prof. Joseph L. Browne, Ph.D., for his definitive book on the history of Crofton, *From Sotweed to Suburbia: A History of the Crofton, Maryland, Area: 1660s–1960s*. You will also note among the pages of this book some charming renderings of Crofton landmarks by two local artists, Mildred Bottner Anderson and Glenn B. Carpenter.

Do you remember Linthicum Walks, Hall's Grove Farm, Middle Plantation, the Anne Arundel Free School, Walch's Grove General Store, the Pigeon House Inn, and Staples Corner? If only there were more pictures. Photographs, like memories, fade and fall between the cracks of our lives, only to emerge occasionally from under some old pile of books or behind a cabinet. I wish I could have found them all and rescued them for this book. Unfortunately, I could not. Perhaps additional photographs will emerge for another edition at some time in the future.

One
PLANTING FOR THE FUTURE

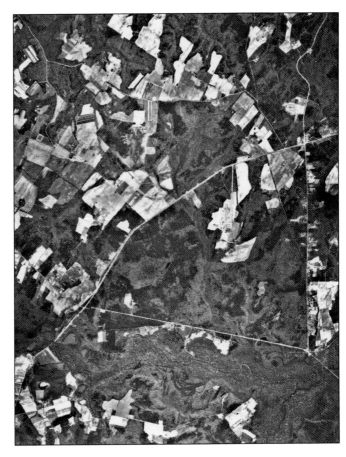

An aerial photograph of the "Crofton triangle" dated 1943 is notable for the heavily wooded acreage dotted with farmland. Clearly visible are the southern leg of the triangle, Defense Highway (Route 450); the eastern leg, Davidsonville Road (Route 424); and the western leg, Crain Highway (Route 3). (Courtesy of the Ann Arrundell Historical Society [AAHS].)

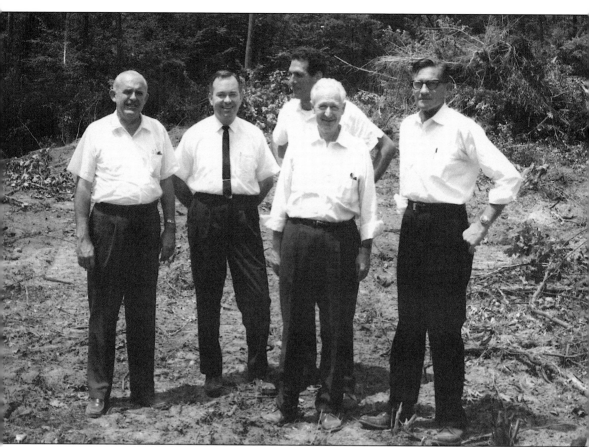

Hamilton Crawford and his development team pose at the 1963 ground-breaking ceremony for Crofton. The men are in shirtsleeves on that muggy July day. From left to right are developer Hamilton Crawford, architect Joe La Borden, civil engineer Ken Adelberry, executive vice president of Crawford Corporation Carl Norcross, and vice president of land development Howard Davis. Fifteen months later, Crawford Corporation held the grand opening of the village of Crofton. (Courtesy of Becky Daniels and AAHS.)

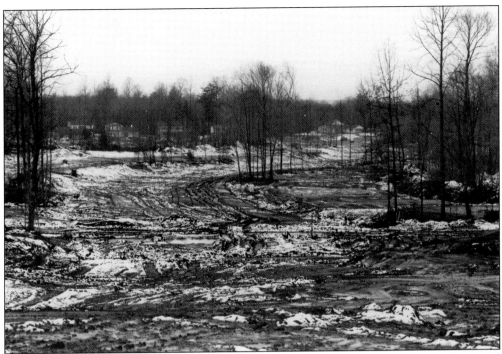

Heavy equipment bulldozed the lush woodlands and evened out the irregular terrain that would become streets and parkways, home sites, and playgrounds. Hamilton Crawford was adamant about maintaining the park-like atmosphere. According to Joseph L. Browne's *From Sotweed to Suburbia: A History of the Crofton, Maryland, Area: 1660s–1960s*, 25 percent of Crofton's acreage was dedicated to parks, and a 3-mile parkway encircled the community. (Courtesy of the Crofton Town Hall archives [CTH].)

Glossy brochures and packets of information served to enlighten prospective buyers and businesses to the advantages of Crofton. Note the map from one such brochure indicating the community's proximity to Washington, D.C., Baltimore, and Annapolis. The prominent Crofton logo, at the upper right and on the map, can still be seen on the decorative, wrought-iron gates at one of the Crain Highway (Route 3) entrances to Crofton. (Courtesy of JLB.)

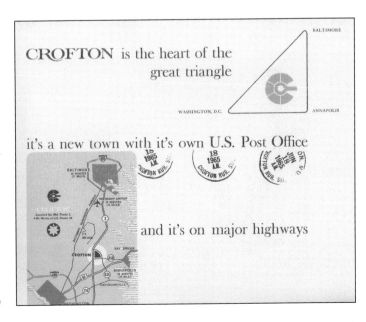

The farm lanes and woods that will disappear were still visible in this 1964 photograph, taken as construction of Crofton got underway. (Courtesy of CTH.)

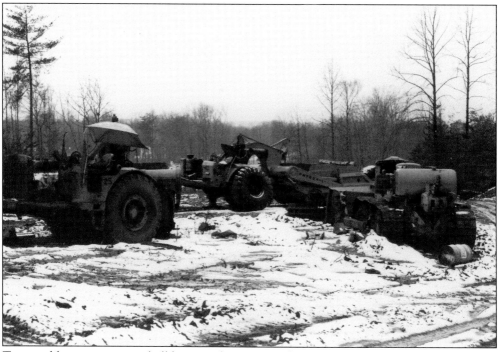

Trees and lanes give way to bulldozers and tractors as the engineers carve out streets and culs-de-sac off the parkway for the nascent community. (Courtesy of CTH.)

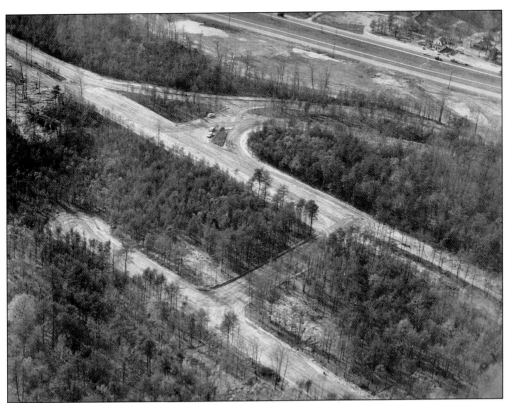

By late fall of 1963, Crofton Parkway can be seen (center, diagonally from the upper left to lower right) in this aerial photograph. Crain Highway (Route 3) is at the top. The area is still heavily wooded. (Courtesy of CTH.)

This memo from Carl Norcross, vice president of land development, to Hamilton Crawford dated January 22, 1963, explains the tone Crawford is creating for Crofton—an atmosphere both rustic and refined, "a pleasant place to live" with an "aura of glamour." Norcross particularly worries about countering the hot summer climate of the region with references to "highlands," "hills," and "forests." It is interesting to note that the choice of the name Crofton infers all those things. A croft is an English meadow or pastureland. (Courtesy of JLB.)

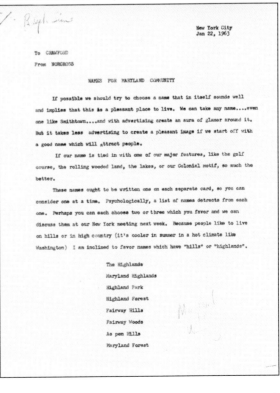

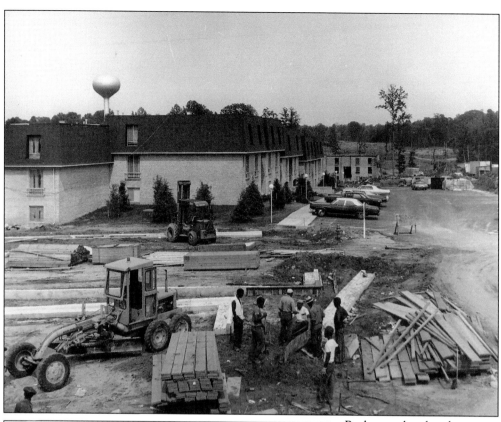

Both completed and occupied Carlyle apartments and the ongoing construction of streets, sidewalks, and additional apartments are apparent in this 1964 photograph. (Courtesy of JLB.)

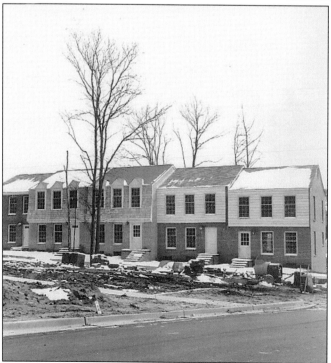

Hamilton Crawford carefully incorporated English-style architectural details in the townhouses as well as in the community office buildings and shops. Shutters, brick trim, paned windows, street names, and names of model homes all contributed to the gentrified character Crawford tried to create for Crofton. (Courtesy of JLB.)

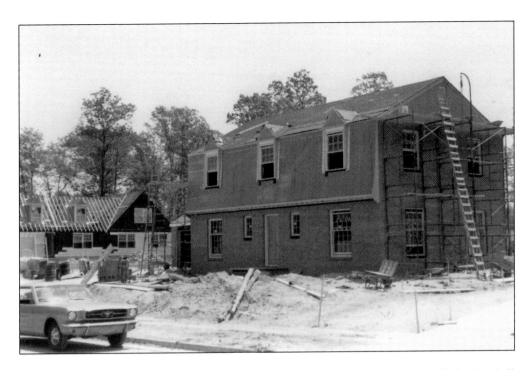

One of the homes completed in the spring of 1965 belonged to Mary Betty "MB" and John Pritzlaff. Their home on Eton Way promised a lifestyle the Pritzlaffs wanted for their young daughters, Susan and Carol. Pritzlaff remembers joining the golf club so the girls could enjoy the swimming pool in the summertime. (Both courtesy of John Pritzlaff.)

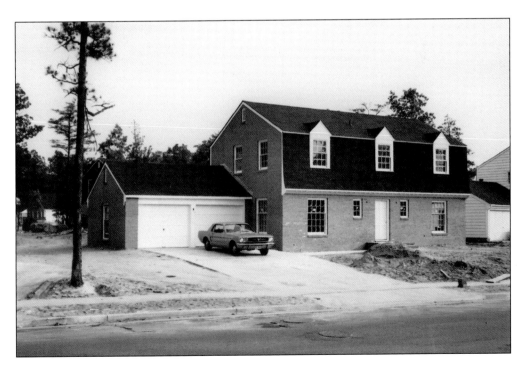

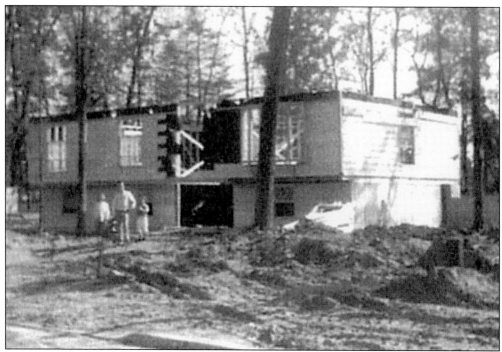

The Phillips family—Ruth, Bill, and son Bob—stand proudly before their new house, still under construction. (Courtesy of JLB.)

Carefully manicured and thinned woods border Crofton Parkway as photographed by the Crofton Garden Club in 1986. (Courtesy of the Crofton Garden Club [CGC].)

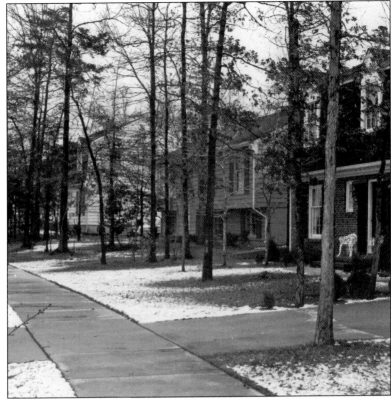

New homes line the streets. A light dusting of snow and stately trees, spared during construction or planted by the developer, contribute to the atmosphere of serenity and dignity that Hamilton Crawford originally dreamed of creating. (Courtesy of CTH.)

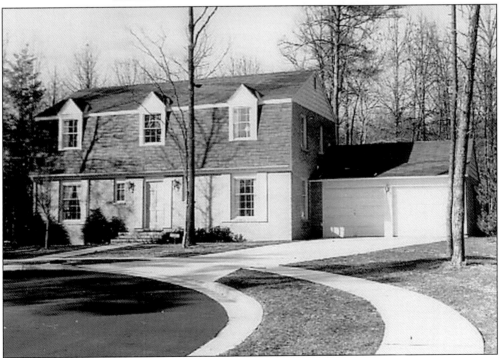

The first model home awaits admiring buyers. (Courtesy of JLB.)

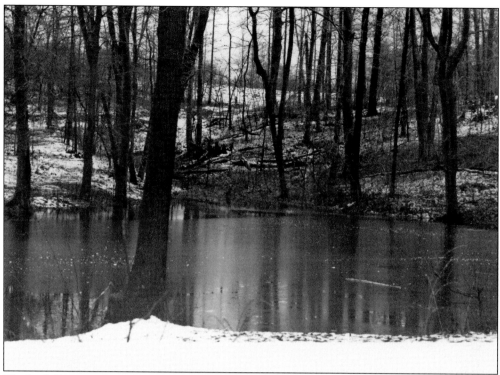

The Little Patuxent River feeds the streams and fills the low areas of Crofton. The above photograph of the river in 1970 and the picture below of the river in 2009 reflect the care both the developer and the residents have taken to protect the streams and rivers of Crofton. A growing population and heavy use of the area have not destroyed the beauty of the Little Patuxent. (Above courtesy of CTH; below courtesy of Carolyn Finelli [CF].)

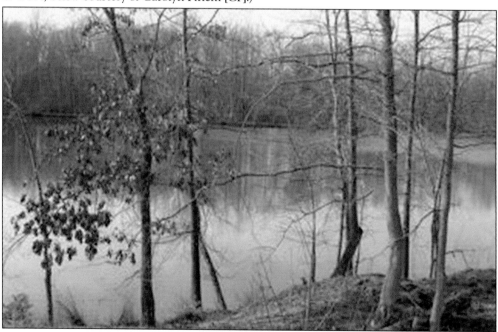

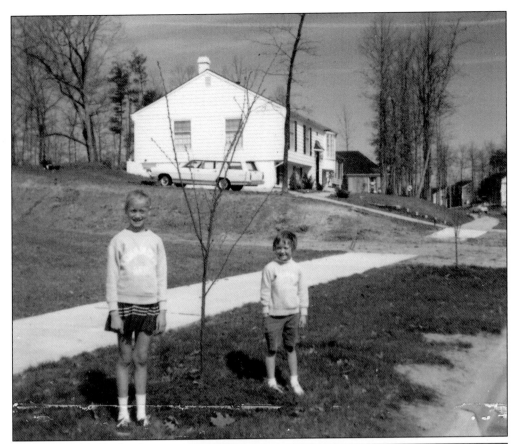

In keeping with Crofton's love of nature and concern for the aesthetics of the community, in 1971, Katherine Callahan spearheaded a movement to plant ornamental Japanese cherry trees along Crofton Parkway. Initially, only 12 trees were authorized, but Callahan's vision caught on, and before long, over 1,000 ornamental cherry trees were planted along Crofton Parkway. The above photograph is of Linda (left) and Cynthia Callahan (right) with their cherry tree. The photograph at right is of Katherine Callahan and her handiwork. (Both courtesy of Katherine Callahan.)

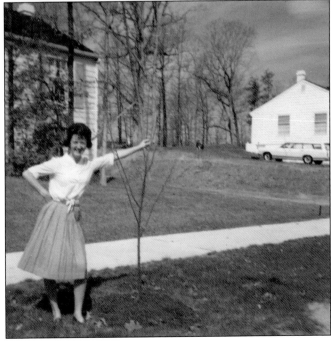

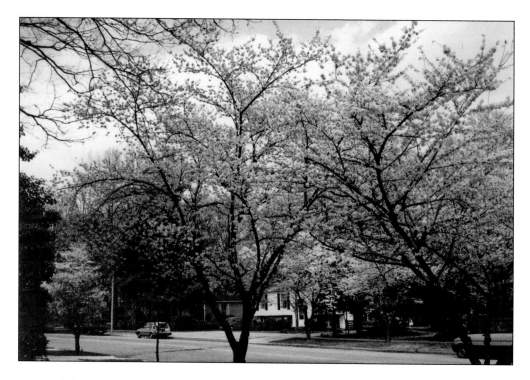

What a difference 20 years make. These photographs, taken in 1993, twenty years after the planting project, bear witness to the vision of Katherine Callahan. Every spring, Crofton's residents enjoy the glory of blooming cherry trees and the carpet of pink petals as the blossoms fall and the trees green out. (Both courtesy of Katherine Callahan.)

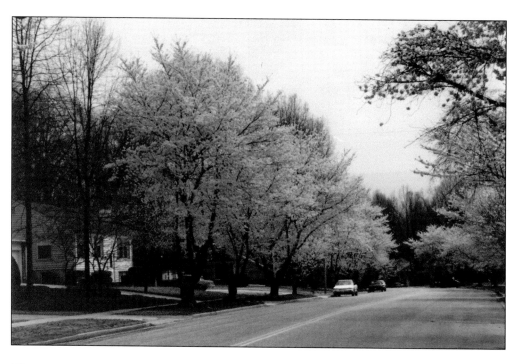

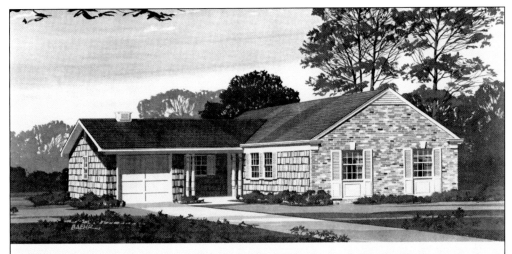

The Brandywine The Crofton Park rancher achieves its distinctive charm through a combination of brick and hand-split cedar shakes. Inside, there's the added convenience of one-floor comfort... no stairs!

From the sheltered porch at the front door, you enter a spacious, wood paneled foyer with large guest closet. Beyond is the exceptionally large living room plus an attractive dining area.

Off in the sleeping wing are three bedrooms and two complete baths. Each bath has ceramic tile floor and bath areas; each has a glamorous wall-wide illuminated mirror. There's an oversized stall shower in one bath, a built-in vanity in the other.

The colorful kitchen is equipped with lovely wood cabinets and such luxury details as stainless steel sink, stainless range hood, even a chopping block work area! Appliances, all by General Electric, include built-in dishwasher, wall oven, countertop range, two-door refrigerator-freezer, garbage disposer—plus washer and matching dryer in the adjoining laundry. (The laundry has a convenient "mud room" door to the rear lawn.)

Open to the kitchen is a family room where sliding glass doors lead to the rear lawn—so it's easy to keep an eye on the children, indoors or outdoors. And for everyone's convenience, there's direct access to the house from the attached garage!

The Brandywine is centrally air conditioned by G.E., pre-wired for telephone installation and television antenna outlets. Grounds are completely landscaped with many trees and shrubs. Everything's included in the price of the house. And to preserve the beauty of the area, all utilities are underground.

Fireplace or two-car garage available at additional cost.

The Levitt Corporation took over the development of Crofton in 1968 and continued to build and market homes that were both attractive and affordable until 1973. The Brandywine model (above) was one of two ranchers available. Like all the models, the Roxbury had an attached garage. Notice that Levitt homes were built on slabs, unlike the Crawford homes, which had basements. (Both courtesy of Georges St. Clair.)

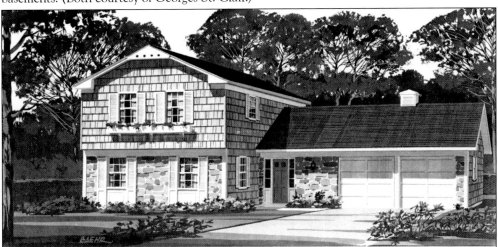

The Roxbury The size and solid look of this handsome four-bedroom colonial are truly impressive—and so are the completely landscaped grounds!

Indoors the first floor fans out from a spacious foyer with an L-shaped guest closet. The huge living room spreads out across the front of the house with a large formal dining room just beyond. Family room is at the rear, kitchen and breakfast alcove straight ahead, with sliding glass doors to the rear lawn. Also on this floor is a glamorous guest powder room with built-in vanity.

In the luxuriously detailed kitchen you'll find an abundance of lovely wood cabinets and plenty of counter space. Also a stainless steel sink and a stainless range hood to waft away cooking odors. Appliances are all by General Electric and include built-in dishwasher, automatic wall oven, countertop range, two-door 13.5 cu. ft. refrigerator-freezer, and garbage disposer; plus washer and matching dryer in the separate laundry.

Particularly noteworthy is the family room with exposed ceiling beams adding to its charm.

Up the handsome stairway you'll find four exceptionally large bedrooms and two oversized baths. Both baths have ceramic tile floors, ceramic tile tub and shower areas, built-in vanities, and wall-wide illuminated mirrors.

The Roxbury is centrally air conditioned by G.E., pre-wired for telephone installation and television antenna outlets. The two-car garage, with "mud room" entrance from the rear yard, has extra overhead storage space accessible with pull-down stairs. Grounds are completely landscaped with many trees and shrubs. Everything is included in the price. And to preserve the beauty of the area, all utilities are underground.

Fireplace available at additional cost.

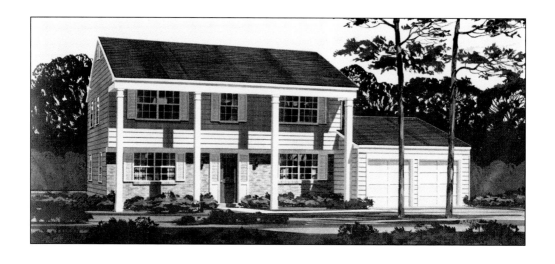

The Galway (above) and Jordan models are illustrated here. The Galway has just a hint of antebellum splendor with its two-story column posts across the front. (Both courtesy of Georges St. Clair.)

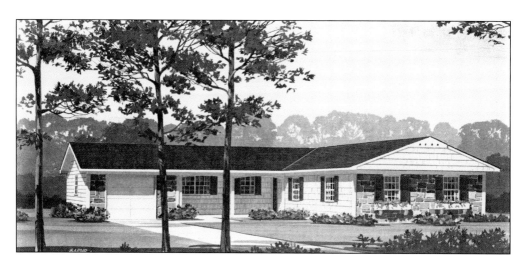

The first two issues of the *Crofton Courier* carry personal letters from Hamilton Crawford to the community. Residents are encouraged to submit articles and letters for publication. Jim Plymire and Bob Schuh had regular columns on golf and community activities. (Both courtesy of JLB.)

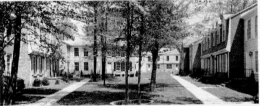

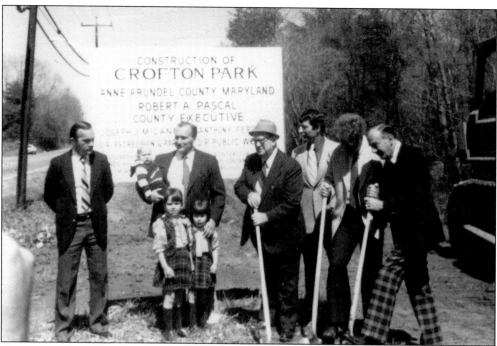

Continuing the commitment to maintaining Crofton's suburban atmosphere, the early 1970s brought ground-breaking for Crofton Park. From left to right are Gene Budowski, Robert Pascal with his children, Charles "Chucky" Chiles, two unidentified officials, and Jack Williams. (Courtesy of the CGC.)

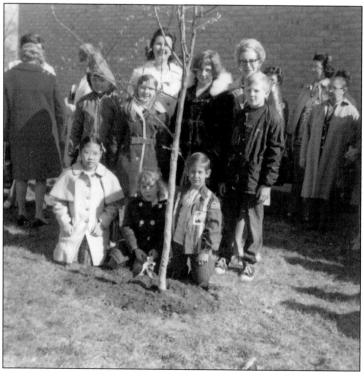

Crofton Woods Elementary School nurtured the community's "greening of Crofton" with tree plantings on Arbor Day. Children, parents, and faculty gather around a newly planted tree in the 1972 photograph. (Courtesy of the CGC.)

Progress had to be planned for. As part of the Levitt Corporation's sales material, this drawing lays out plans for the shopping park. (Both courtesy of Georges St. Clair.)

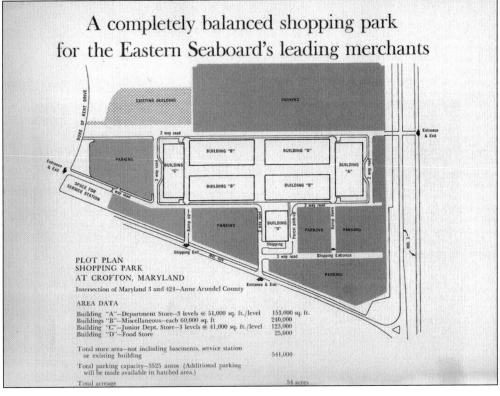

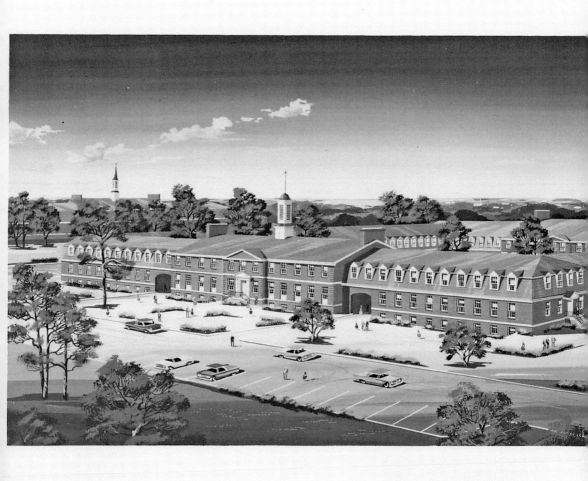

WALTER G. PETER, A.I.A. Architect
WILLIAM M. HAUSSMANN, A.I.A.
THOMAS J. STOHLMAN, A.I.A. Associates

CROFTON
MARYLAND
OFFICE PARK

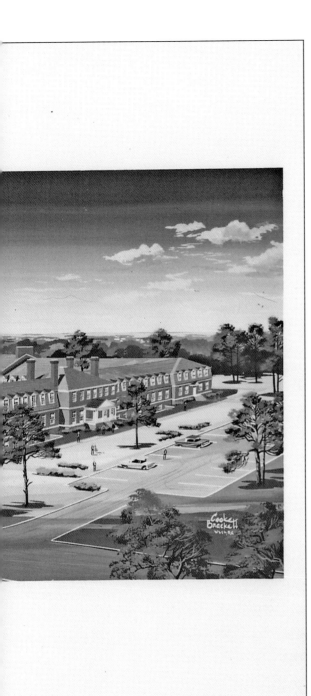

This architectural drawing depicts the business area envisioned for Crofton. An expanded business park was planned just off Crain Highway at Crawford Boulevard. A portion of the projected structure was completed and is used to the present for professional offices, small businesses, and shops. (Courtesy of Georges St. Clair.)

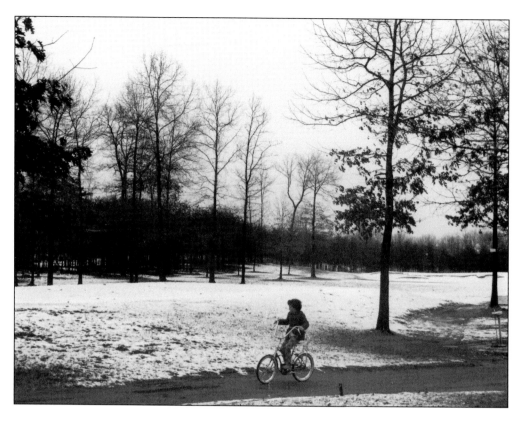

These two photographs taken in 1964 reflect the dream realized. Hamilton Crawford's original plan for a bucolic setting where middle-class families could safely raise their families had been achieved. (Both courtesy of CTH.)

Two
FOUNDATIONS FOR THE AMERICAN DREAM

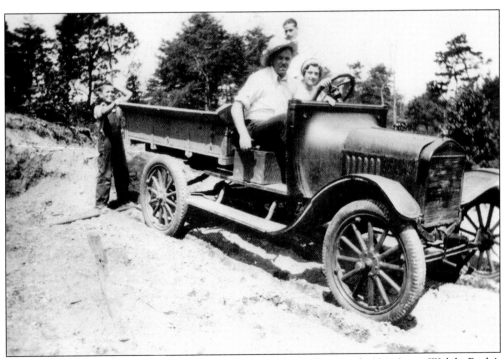

Rudy Walch (age 6) enjoys a ride on the back of a farm truck around 1924. Anna Walch, Rudy's sister-in-law, is in the driver's seat. (Courtesy of Juliana Walch Ammon [JWA].)

After World War I, a wave of European immigrants, particularly from Germany, arrived in the area that became Crofton. Families, including John and Julia Walch, cleared land just west of what became Crain Highway/Route 3, across from the main entrance to Crofton today, and laid foundations for an early community, Walch's Grove. (Courtesy of JWA.)

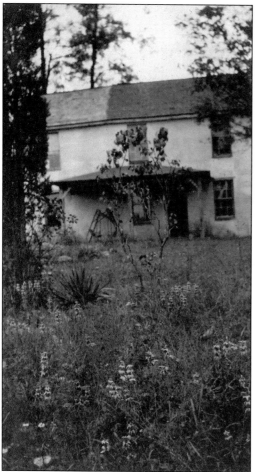

The wildflowers dotting the foreground of this picture typify the gentle wilderness that prevailed in the region that was to become Crofton. The worn, stucco farmhouse served as a haven for some hardworking farm family. (Courtesy of JWA.)

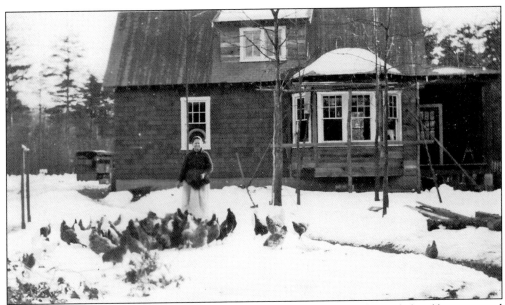

Julia Gailor Walch feeds her flock of chickens in the 1920s. Notice the house behind her; it served the Walch family well through several incarnations. A later incarnation of the house was the Red Barn Liquor Store. (Courtesy of JWA.)

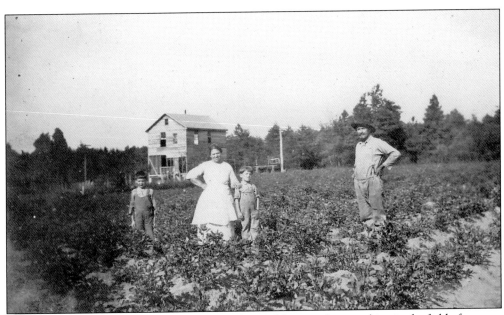

From left to right, Rudy, Julia, Leonard, and John Walch pause from working in the field of peppers for a family photograph in the 1920s. Some itinerant photographer wandered the countryside capturing families like the Walchs. (Courtesy of JWA.)

This undated photograph captures a traditional farm building in the region with clapboard siding and tin roof; the window suggests it might have been used as a cabin. (Courtesy of AAHS.)

This milk house was still standing in the 1980s on one of the remaining Hopkins Farm tracts in the Crofton area. The milk house was where dairy farmers gathered their milk cans to await pickup. Sometimes dairies sold milk and other dairy products locally from their milk houses. Like old tobacco barns, the milk house will soon be only a novelty in a photograph. (Courtesy of AAHS.)

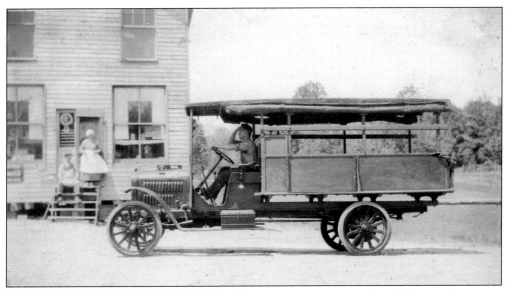

Pumphrey's Market, another small business in the area, appears here in the 1920s as both a private residence and general store. Notice the tidy, starched aprons on the shopkeepers. If one could step inside, one would see jars of boiled eggs, crocks of pickles, a glass case of meats and cheeses, bread, and condiments. The farm bus/truck may be picking up passengers and produce for one of the "big cities," Washington, Baltimore, or Annapolis. Visitors to the area came from as far away as Philadelphia. (Courtesy of JWA.)

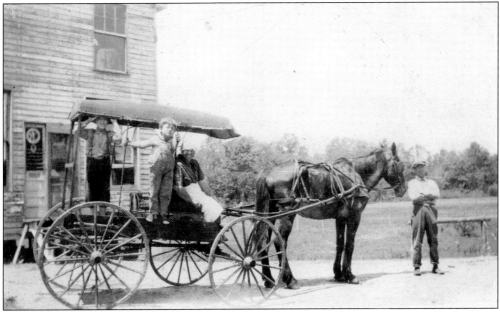

Transportation was in transition in the 1920s. Both animal power and gasoline engines were used to transport goods and people. Walch's Grove depended on both forms of transportation for getting produce to market and guests to and from Washington, Baltimore, and Annapolis for recreating. This photograph, also seen on the cover, shows Julia Gailor Walch on her wagon around 1920. Her sons from left to right are Rudolph, Leonard, and Joseph, near Heinrich the mule's head. (Courtesy of JWA.)

Here is the house that would eventually become the Red Barn Liquor Store. Notice the family car and truck in the yard. Both the Walch Market and Pumphrey's Market were a combination of business and family residence. The front room housed the store, while the family lived in the rooms behind and above the market. The picture dates to some time in the early 1920s. (Courtesy of JWA.)

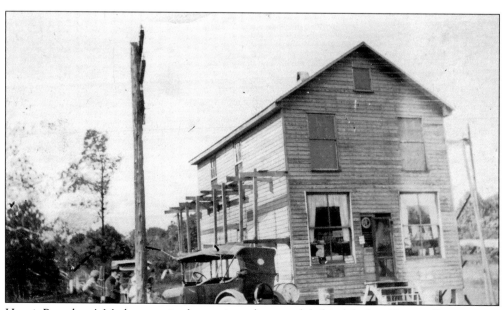

Here is Pumphrey's Market, seen in the previous photograph behind the bus. Eventually gas pumps would be added to the successful market. (Courtesy of JWA.)

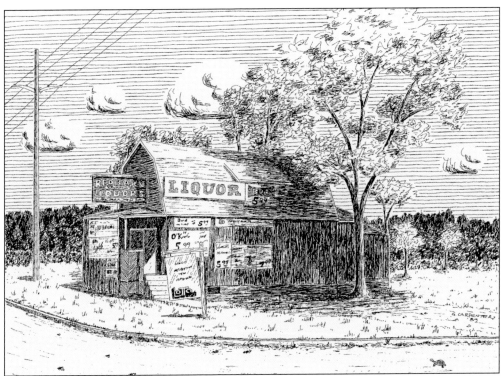

And here is the Red Barn Liquor Store as it appeared in the 1970s, the later reincarnation of the old house. The pen-and-charcoal rendering is the work of local artist and longtime resident of Crofton Glenn Carpenter. Carpenter rendered drawings of many of the local sights and landmarks of Crofton from 1968 until his death in 2004. (Courtesy of Gary Carpenter.)

Many farms had a barnyard not unlike the one in this undated photograph. The cows provided milk and meat; the mule pulled the wagon and plow. Everyone—man, woman, child, and animal—earned his or her keep. (Courtesy of JWA.)

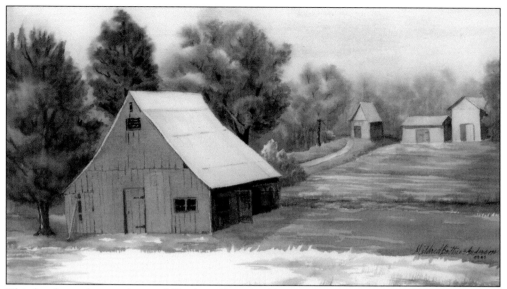

This lovely rendering of several Hopkins Farm buildings is an original watercolor completed in the 1990s. The traditional, pitch-roof barn and outbuildings along Bell Branch Road are still standing. This watercolor is one of many done by a lifelong resident of the Middle Plantation and the Crofton area, Mildred Bottner Anderson. Anderson has written a book, *Memories: A Piece of History: Barns, Churches, Gardens, Houses, Landmarks and Landscapes around Maryland*, combining her paintings with her observations and recollections of the images. (Painting by Mildred Bottner Anderson [MBA].)

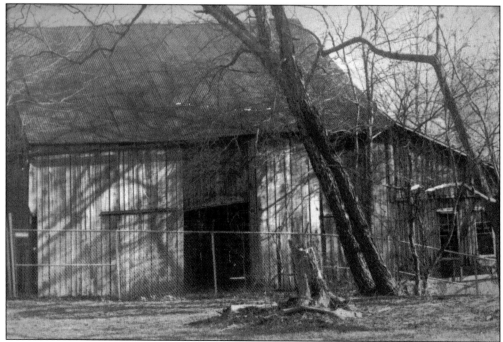

This poignant photograph is the ramshackle barn at Linthicum Walks, probably taken in the late 1950s. The barn caught fire and burned to the ground before the Linthicum Walks Historical Society could rescue and restore it. (Courtesy of the Linthicum Walks Historical Society.)

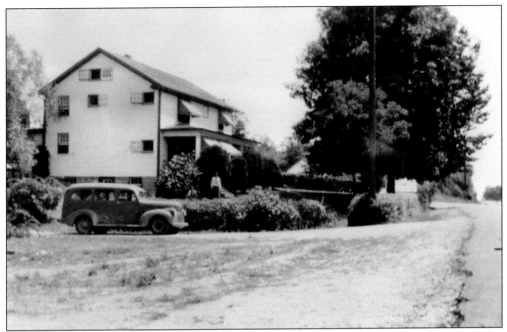

Bartgis Corner, later known as Staples Corner, has changed a great deal over the years. This 1920s photograph shows Davidsonville Road (Route 424) to the far right and Defense Highway (Route 450) in front of the house. Notice the unidentified seated woman and her companion in his white shirtsleeves and tie. (Courtesy of AAHS.)

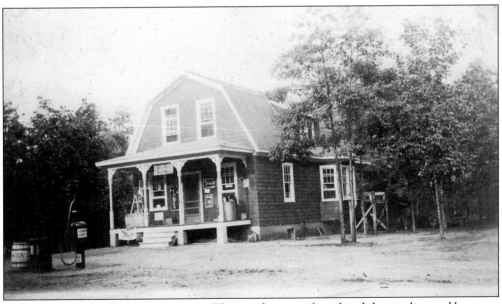

Walch's Grove had the local gas station. The wooden water barrel and the gasoline and kerosene pumps in the front yard service the automobiles and trucks. Those pumps required human power to pump out the fuel. On the porch was a bale of straw and, beneath it, a hand-painted banner: "Drinks." Perhaps one could sip a drink while relaxing on the hay bale. (Courtesy of JWA.)

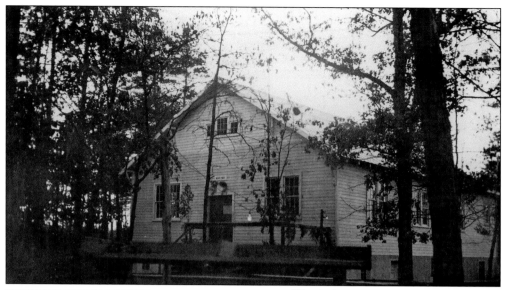

The industrious immigrant families worked hard and played hard. One of the first large public buildings was the Dance Hall and Beer Garden at Walch's Grove, pictured here. Long benches in front provided a place for tired dancers to relax and cool off. There was no air-conditioning or even electric fans. Wooden kegs of beer were cooled by blocks of ice. (Courtesy of JWA.)

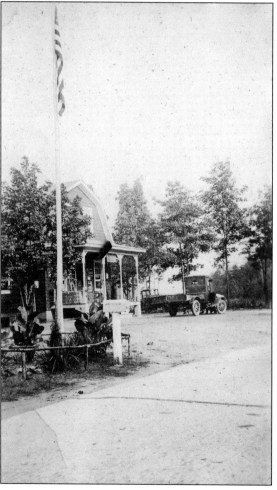

Land was plentiful and inexpensive. Tobacco had leached the nutrients from the land. Restoring the soil was labor intensive, and labor was expensive. Immigrants arrived from Europe eager to buy land. Their knowledge of farming made land a wise and lucrative investment. Many were Germans starting over after World War I. In Maryland, there was space to grow and build during the first half of the 20th century. Notice that Walch's Grove gas station and market (see page 37) has added a flagpole and flower bed, trees are growing, and two trucks are in the yard—prosperity reigns. (Courtesy of JWA.)

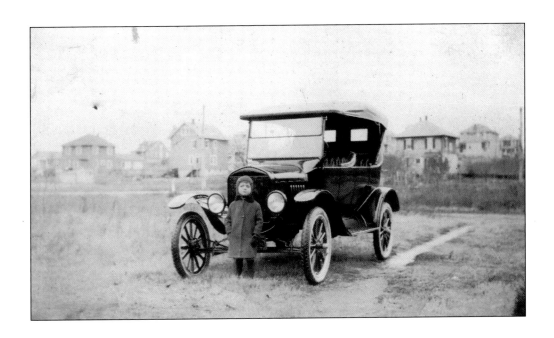

Boys will be boys. The growing availability of cars and trucks allowed every family to dream of owning one. In these photographs, small boys dream big, whether posing with Dad's new car or his own soapbox racer. It is easy to see why racers like the one Lenny Walch is driving were called "soap box" racers. The wooden boxes in which bars of soap were packed were, with a little imaginative work, exactly the right size and shape for a fast racer. Notice the snazzy wheels. (Courtesy of JWA.)

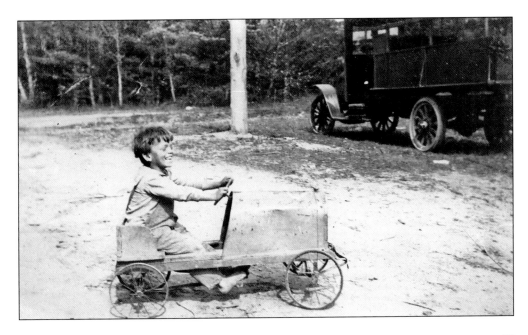

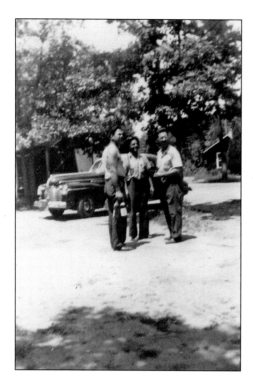

After a hard day's work, having a beer, perhaps just root beer, with friends has been a long-standing tradition. The three fellows at left stand near their sedan parked in the yard. Sometimes, a good laugh is as much fun. The fellow in the photograph below, John Walch Sr., seems to be playing the tough hombre with his mustache, cigar, and six-guns. (Both courtesy of JWA.)

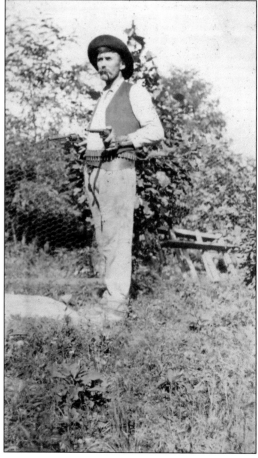

Crofton's tradition of organized athletics, encouraging neighbors to play and learn together, goes back a century. The unidentified baseball player in this photograph looks like he is enjoying himself. It looks like this fellow played for a team called the "Athson." (Courtesy of JWA.)

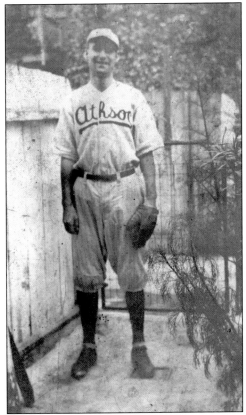

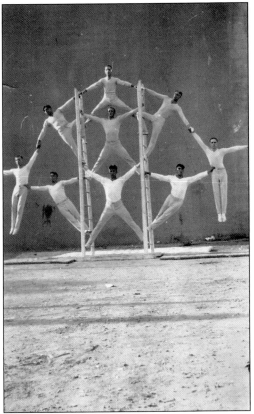

These nine athletes are exhibiting some pretty impressive teamwork. Walch's Grove seems to have had a fairly sophisticated gymnastics program run by Anthony Walch. This team appears to be integrated, another way the area that became Crofton seems to have been ahead of its time. (Courtesy of JWA.)

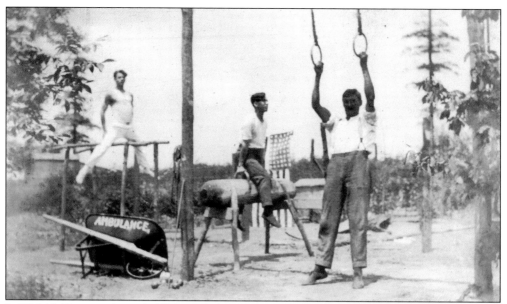

In Walch's Grove in the early 1920s, ambulance services were a bit primitive, as can be seen in this picture of Anthony Walch (far left) and two fellow gymnasts. The ambulance, in the foreground, seems to have run into some mechanical problems. (Courtesy of JWA.)

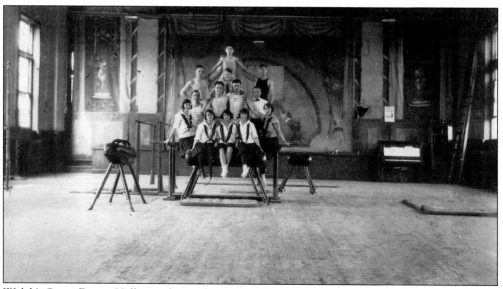

Walch's Grove Dance Hall served as a rehearsal hall for the gymnasts posed in this picture. Notice the poster beside the stage and the well-used dance/gym floor. (Courtesy of JWA.)

Posing on a stump seemed to have been popular. Ethel Chaney Walch, married to Anthony Walch, makes a pretty picture in ruffles and white hose and shoes. The happy boy is Leonard Walch. (Both courtesy of JWA.)

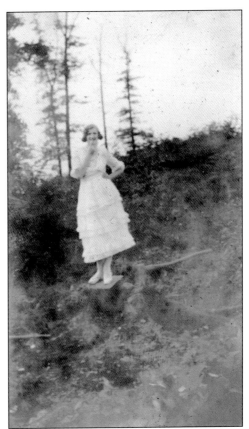

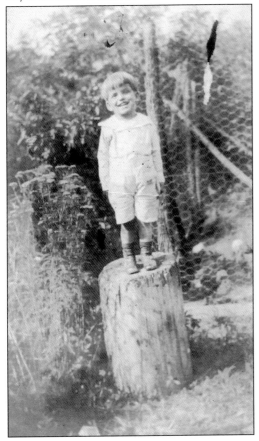

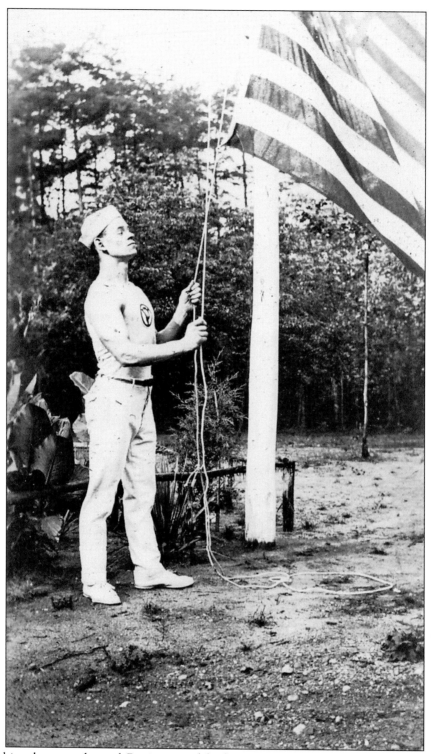

Some things have not changed. Patriotism and displaying our nation's flag has been, and continues to be, important to local residents. (Courtesy of JWA.)

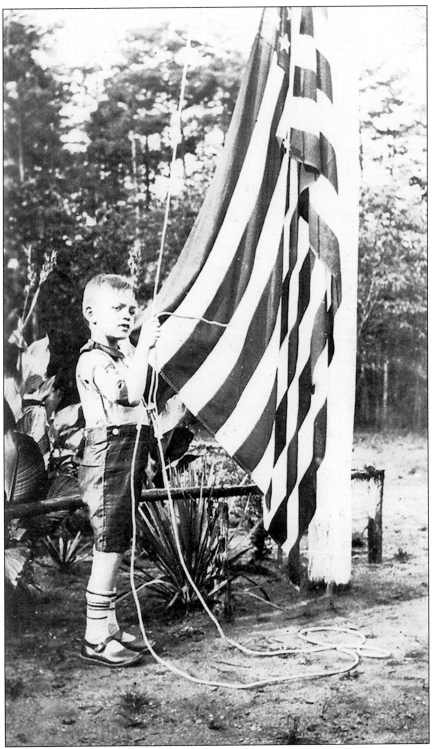
Even small children did, and still do, take pride in their country and its symbol, the American flag. (Courtesy of JWA.)

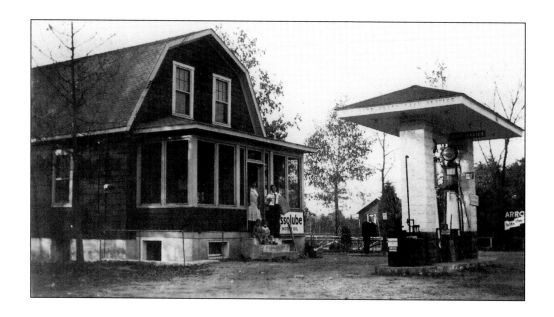

As the region grew and transportation improved, independent businesses prospered, as these photographs attest. The little gas station above had a general store and served the same purpose as gas and convenience stores dotting the highways today. Approximately 10 years separate the pictures. The photograph below from the 1930s captures a thriving service station and the entrance to the picnic grove and riverside shore. Walch's Grove was the place to come for fun. (Both courtesy of JWA.)

Three
COMMUNITY ROOTS

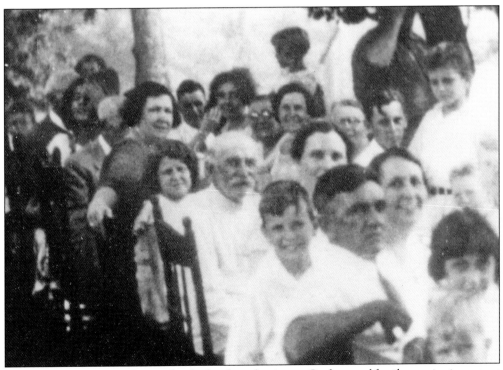

Family was important to the people who lived in what is now Crofton, and family remains important to the Greater Crofton community today. This undated photograph captures the joy of a family gathering at Bright Seat, the home of the Chaney family. The patriarch, Benjamin Chaney, sits in the center of the photograph surrounded by his extended family. (Courtesy of AAHS.)

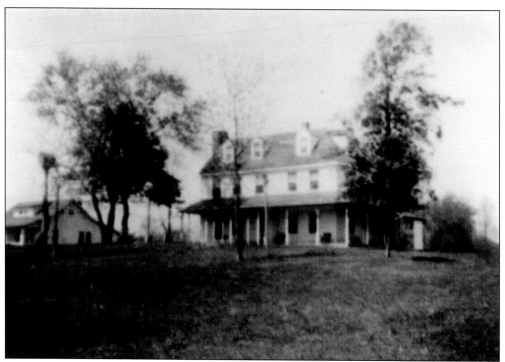

Bright Seat Farm is pictured in this 1930s photograph. Originally owned by Edward Price (1672), the property was bought by James Carroll in 1715. According to historian Joseph L. Browne, Bright Seat was willed to the area's Jesuit priests after Carroll's death. Eventually the Duvall family and then the Chaneys owned the farm. (Courtesy of AAHS.)

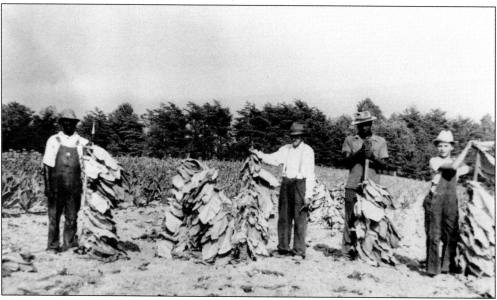

This now familiar image from the cover of Dr. Browne's book, *From Sotweed to Suburbia*, captures the era of tobacco farming. Photographed in the 1940s, these farmers proudly exhibit the harvest on Bright Seat Farm. From left to right are Benjamin Dorsey, Lew Redmiles, Milton Smith, and John Clark. (Courtesy of AAHS.)

These two portraits capture the Ferdinand Duvall family in 1875, during a brief period of peace and prosperity in their tragic lives. Following the Civil War, Annie Linthicum Duvall and her husband, Ferdinand, tried briefly and unsuccessfully to farm over 400 acres—what is now Crofton. Ferdinand's sudden death in 1878 and crushing debt led Annie Duvall to move to Oregon with her two children, Robert and Mayonia. (Right courtesy of AAHS; below courtesy of the CGC.)

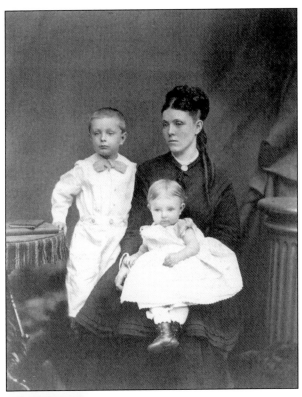

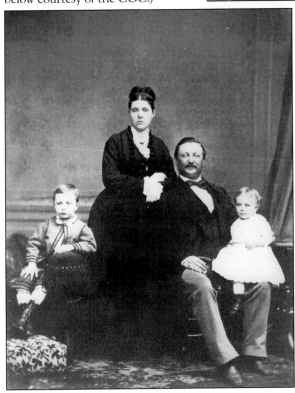

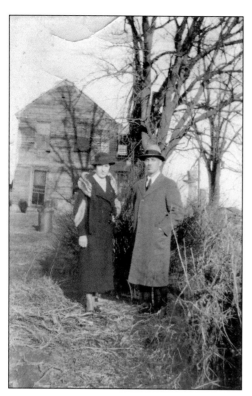

Fifty years after the Ferdinand Duvall family faded from the area, this 1933 photograph captures an unidentified, mature couple standing in their field in the winter sunlight. (Courtesy of JWA.)

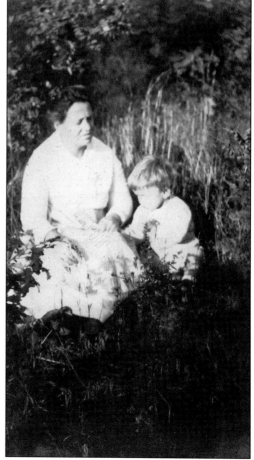

A century ago, mothers held their sons (as Julia Walch does her son Leonard), and children played, carefree, in the fields of wildflowers, as they still do today in Crofton. Today the public parks and playgrounds, not farmers' fields, are the sites for family playtime. (Courtesy of JWA.)

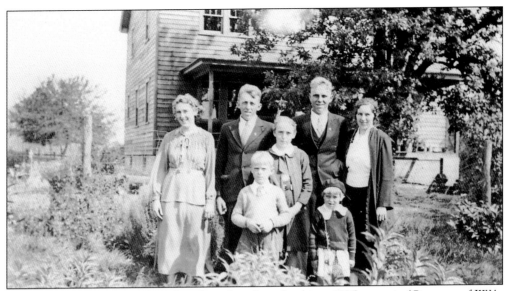
The Henry Doepkens family gathered on their farm for this c. 1925 portrait. (Courtesy of JWA, with the permission of Bill Doepkens.)

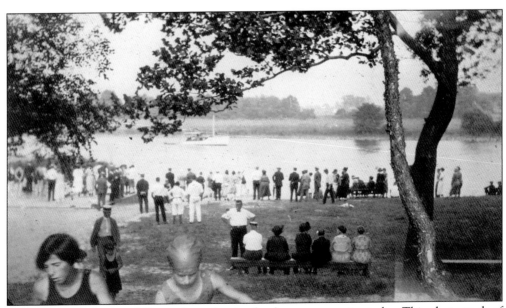
Family fun was not too different from the simple pleasures we enjoy today. This photograph of families enjoying a quiet day at the beach could be any summer Sunday, if the attire was changed just a bit. Notice the pretty watercraft plying the Little Patuxent River. In the foreground, a line of older ladies and gents sit like plump songbirds on the only available bench. People can still enjoy the river just west of Crain Highway. (Courtesy of JWA.)

51

Part of the tragedy that followed the Civil War is reflected in this 1877 public notice of a "Trustees' Sale" of the property formerly owned by William G. Williams. Since he fought on the side of the Confederacy, his property was confiscated and sold at auction. A detailed account of his life and the Anderson family with whom he was closely tied can be found in *From Sotweed to Suburbia*. (Courtesy of AAHS.)

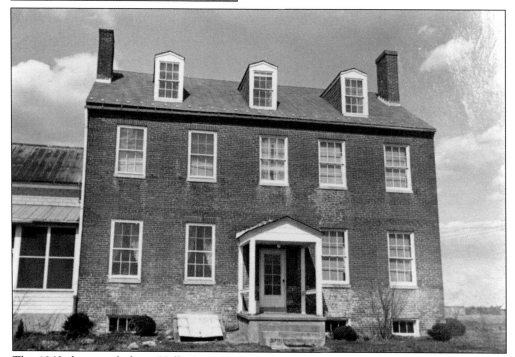

This 1960 photograph shows Hall's Grove Farm, built in 1857 by Absalom Anderson Hall. Barbara and John Gerstner purchased the house in 1910. The home has since been restored and expanded by the current owners, Mary and Kirk Anderson. (Courtesy of AAHS.)

This handsome portrait is of Dr. Asa Anderson in the 1840s. He married Eliza Williams in 1829 and died in 1849, a few months after the death of his only child. Dr. Anderson was only the second physician in the area; he filled the vacancy left by the death of Dr. Elisha Hopkins. Eliza Williams Anderson lived another 30 years and managed over 400 cultivated acres. (Courtesy of AAHS.)

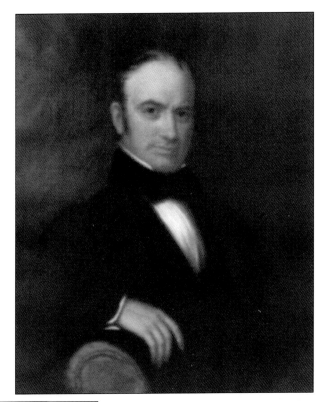

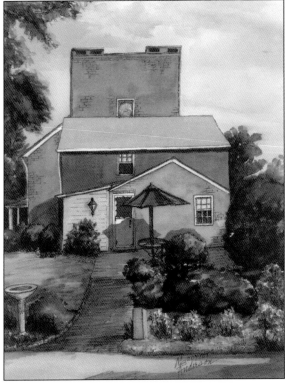

Middle Plantation, remodeled and expanded as seen from its south or garden side, is depicted in this watercolor by the home's owner and resident, Mildred Bottner Anderson. (Courtesy of MBA.)

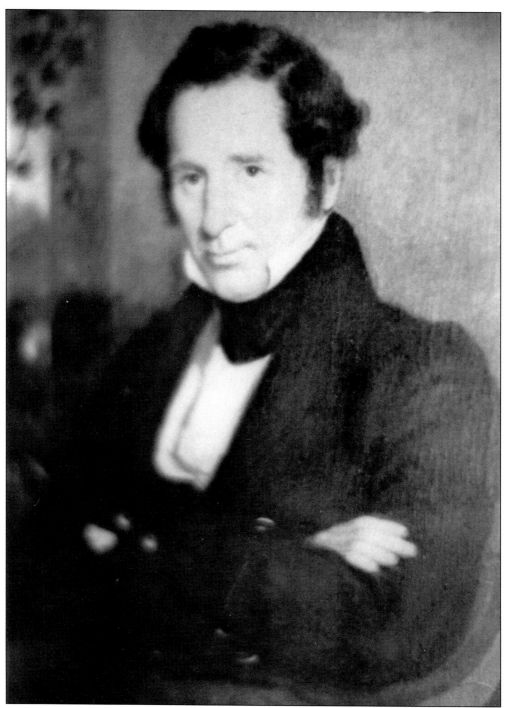

Perhaps the most famous resident of what is now Crofton was the man in this portrait, Johns Hopkins (1795–1873). His success as a businessman and his Quaker faith led him to bequeath millions of dollars (in 1873 dollars) for the founding of three institutions: a hospital, a university, and an orphanage for African American children. See *From Sotweed to Suburbia* for a detailed account. (Courtesy of AAHS.)

Samuel Hopkins, born in 1845, was a younger cousin of Johns Hopkins. Samuel married Elizabeth Linthicum Hopkins. They resided at Rose Hill overlooking Bell Branch Road. (Courtesy of AAHS.)

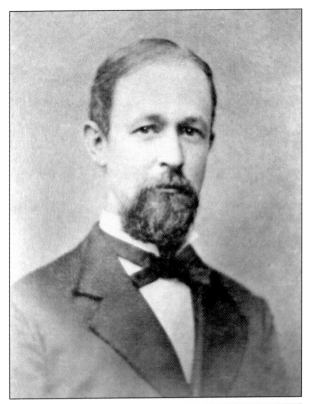

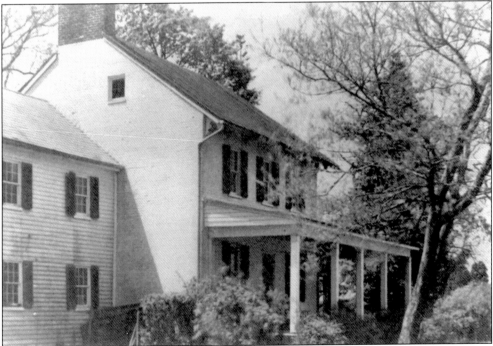

Hopkins House, built in 1770, is one of the homesteads for the Hopkins family. This photograph was taken in 1920. (Courtesy of AAHS.)

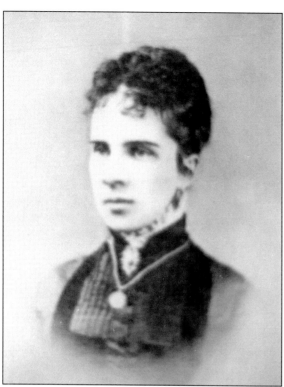

Elizabeth Linthicum Hopkins, pictured here, raised seven children with her husband, Samuel. (Courtesy of AAHS.)

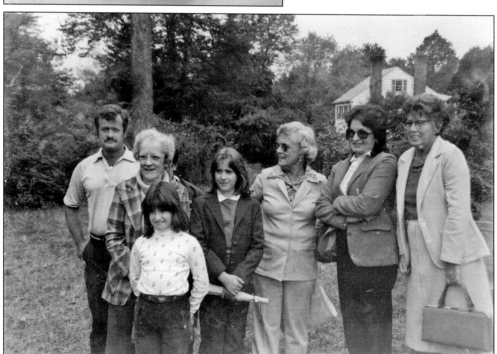

The descendants of Elizabeth and Samuel Hopkins gathered at Linthicum Walks in 1982 for this group picture, taken by Joseph Browne. Included are granddaughters Dorothy Hopkins (second from left), Louise Sullivan (fifth from left), and Jean Shimer (far right). (Courtesy of AAHS.)

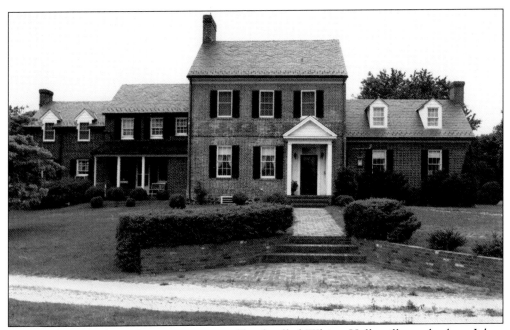

The Hopkins-Duckett House, on a tract of land called Whites Hall, still stands along Johns Hopkins Road. Photographed here in the 1980s, the house exemplifies the stately elegance of the first plantation farms in the area that became Crofton. The home was built some time around 1710, and the first residents were Gerrard and Margaret Hopkins. (Courtesy of AAHS.)

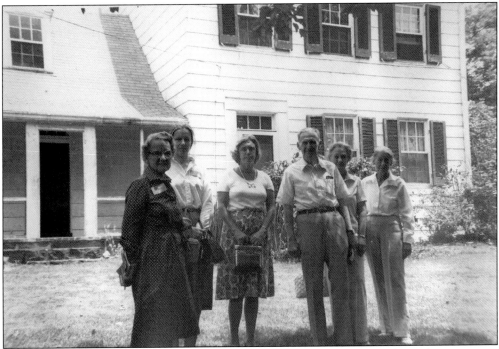

In 1983, descendants of Linthicum Walks returned to the ancestral site to admire the restoration work being undertaken by the Linthicum Walks Historical Society. (Courtesy of the Linthicum Walks Historical Society.)

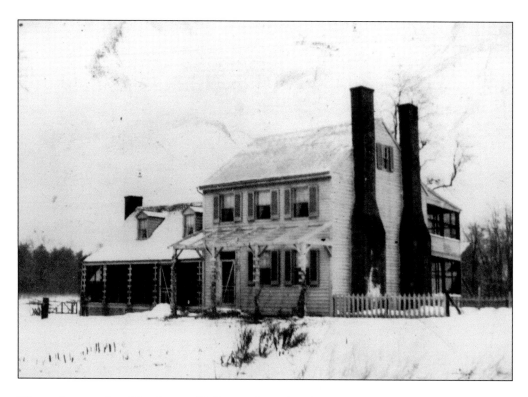

These photographs of Linthicum Walks, in the 1950s above and in 1987 below, illustrate the importance of the timely rescue of the stately old house, originally built around 1780. (Both courtesy of the Linthicum Walks Historical Society.)

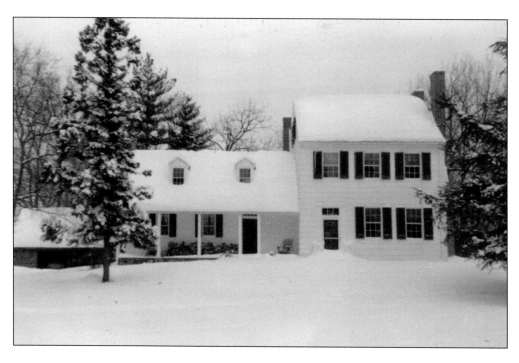

Matilda Linthicum Williams and her husband, Dr. William G. Williams, at one point owned three farms in and around what is now Crofton. According to Dr. Browne's history, what is now the community building for the Chapman Farms development was once the home of Dr. and Mrs. Williams. Their photographic portraits may date from around 1860, perhaps at the time of their marriage. (Both courtesy of AAHS.)

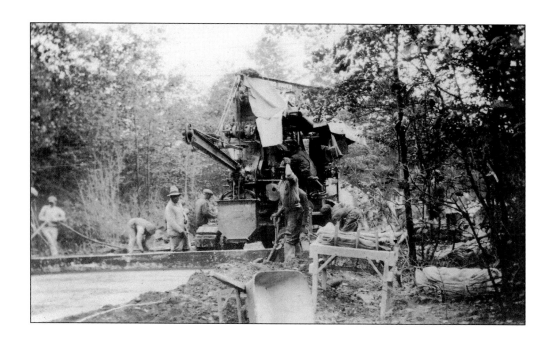

Defense Highway (Route 450) was built in 1927. The road connected the two capitals, Washington, D.C., and Annapolis, Maryland. The highway helped the struggling farms of the region and encouraged city-folk to come out to places like Walch's Grove to recreate and relax. The depressed economic conditions that held the region in its grip after the Civil War and the demise of the area's tobacco crop began to lift. (Both courtesy of JWA.)

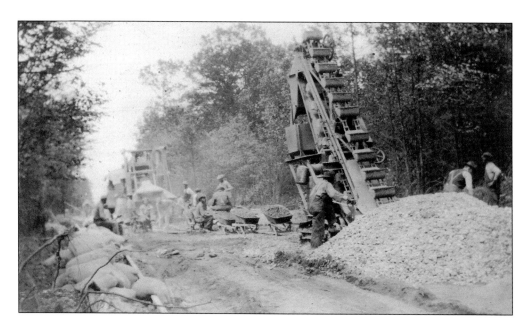

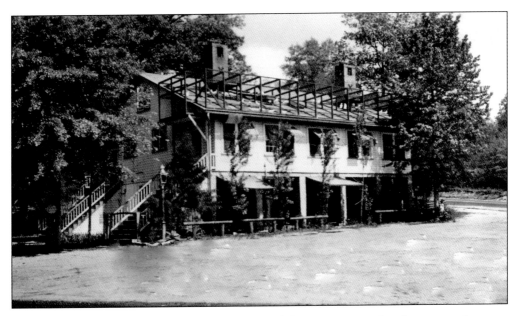

In addition to the gymnasium and dance hall at Walch's Grove, a popular place to stop between Washington and Annapolis was the Pigeon House Inn at the intersection of Crain Highway (Route 3) and Defense Highway (Route 450). The above photograph captures the inn, which kept homing pigeons on the roof, in the 1930s, while the below photograph shows the inn in its 21st-century facade as Jasper's. (Above courtesy of AAHS; below courtesy of Margaret Woda [MW].)

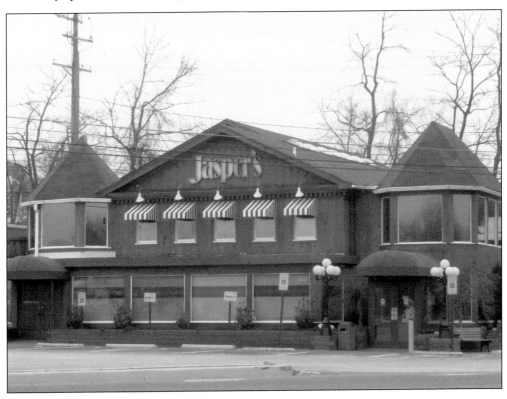

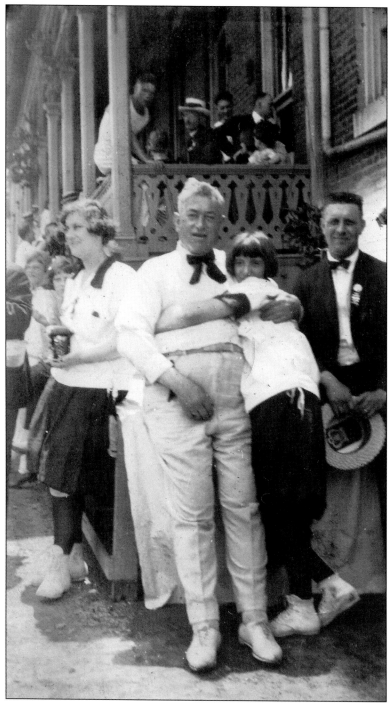

Fred Bottner, in white pants, shirt, and shoes, and unidentified friends seem to be enjoying a festive afternoon at the Beer Hall at Walch's Grove. The Bottners were among the early German immigrants. In the photograph, notice the ladies' bloomers, the straw boater hats (flat-brimmed with a ribbon), and the general air of decorous merriment. Life in the area was becoming a bit more cosmopolitan. (Courtesy of JWA.)

Four
NURTURING THE COMMUNITY

A sense of duty and patriotism infuse with notable dignity the photographs of the early settlers and farmers in the area that is now Crofton: the farmers who had fought in the Civil War, on both sides, and their families who kept the farms going; the immigrants who cleared new farmland and built homes with tall flagpoles in the yards posed for photographers holding flags. That same sense of patriotism and responsibility for one's community carries through in the maturing community of Crofton. This 1994 photograph shows residents saluting the passing colors during the annual Independence Day parade—a mainstay of Crofton's community events. (Courtesy of CTH.)

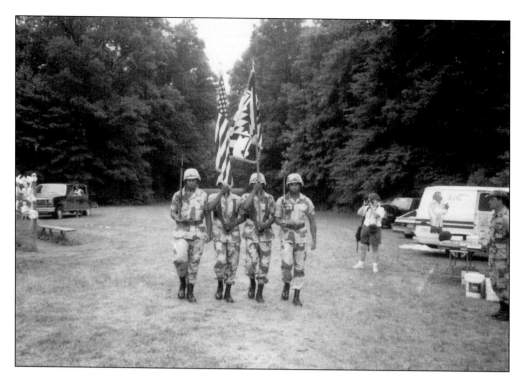

In 1973's Fourth of July parade, the color guard (above) participated in a ceremony (below) honoring the region's soldiers missing in action in Vietnam. (Both courtesy of CTH.)

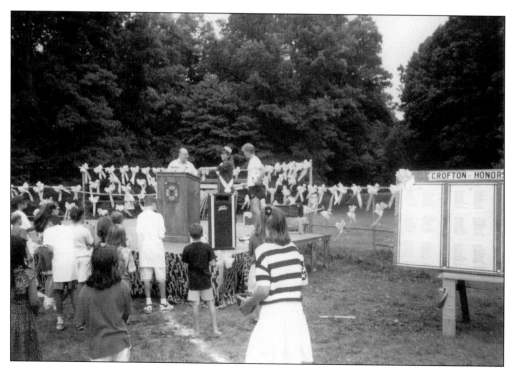

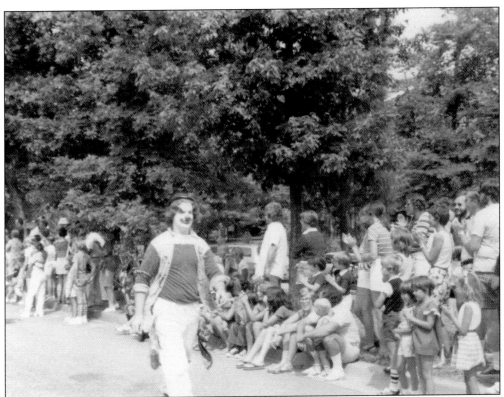

Who is that clown? The photograph above is from the 1970 Independence Day parade. The photograph at right captures the snappy Marine Corps Honor Guard and Drum Corps, marching in the 1971 Fourth of July parade. (Both courtesy of Katherine Callahan.)

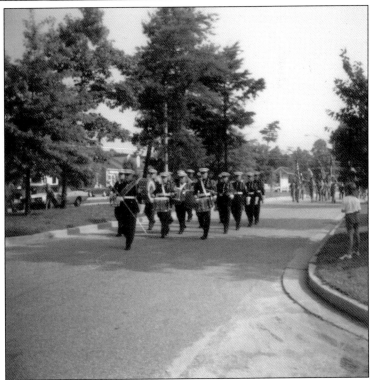

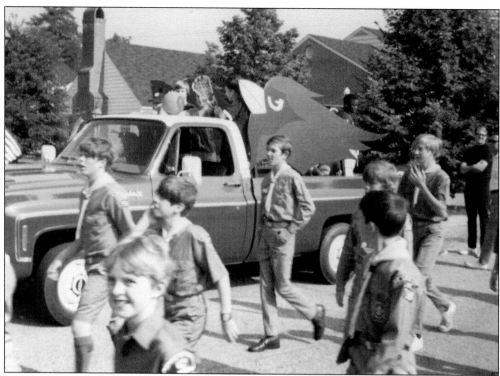

The Boy Scouts accompanied the lacrosse team's float during the 1973 Independence Day parade. (Courtesy of CF.)

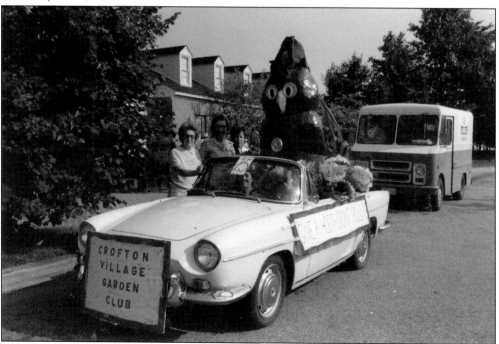

And here in hot pursuit of the lacrosse team's pickup is the Crofton Garden Club with the owl mascot aboard their Studebaker convertible around 1973. (Courtesy of the CGC.)

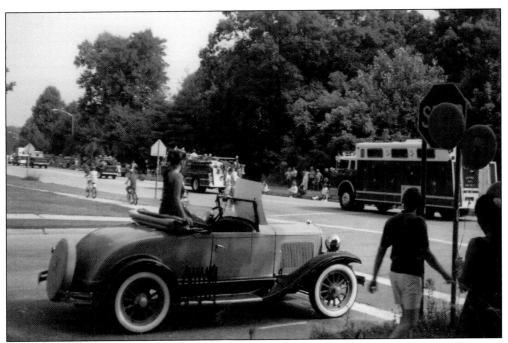

Not to be outdone, the 1973 parade had its share of princesses, too. The above photograph captures the parade queen atop her antique car. And below, an Indian princess on her favorite steed pedals as fast as she can to keep up with the parade. (Both courtesy of CTH.)

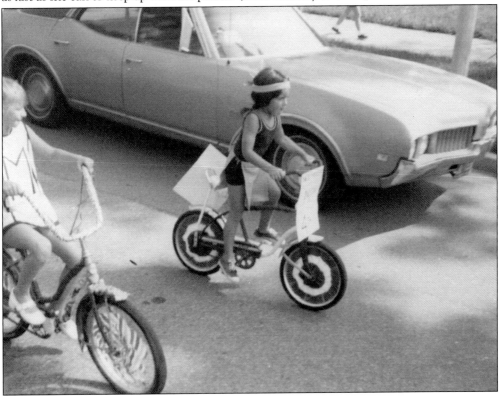

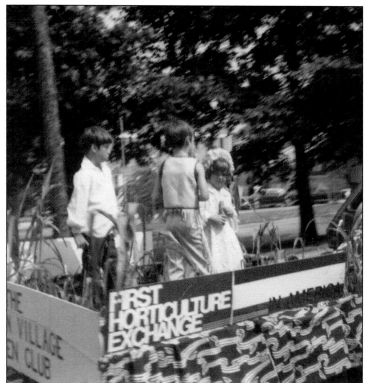

In keeping with the history of the area, the Crofton Garden Club encouraged children to explore horticulture. The budding botanists and farmers on this 1974 float are obviously modeling themselves after the colonists who, in the 18th century, cleared and farmed the land that is now Crofton. (Courtesy of the CGC.)

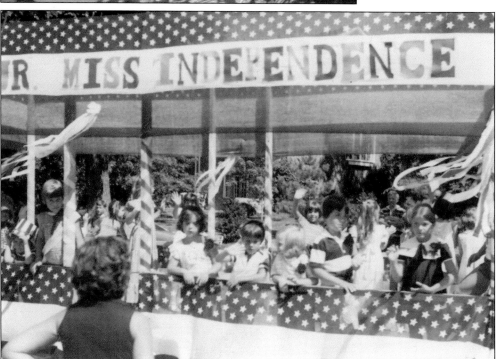

The Independence Day parade of 1976, the Bicentennial, included this "Our Miss Independence" float. (Courtesy of CF.)

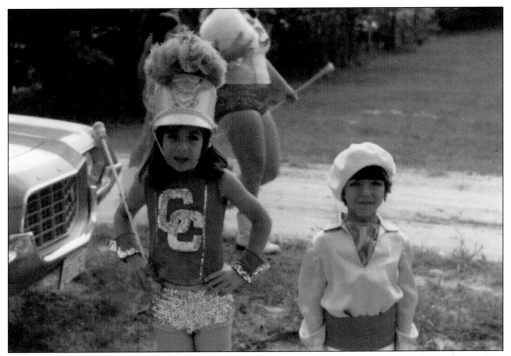
Drum majorette Gina Finelli and her brother Nick dressed up for the 1977 Independence Day parade. (Courtesy of CF.)

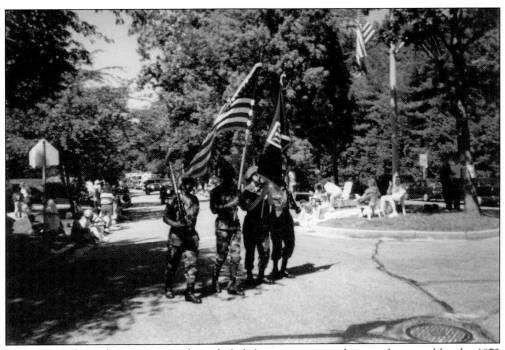
The 1994 Independence Day parade included this impressive color guard, not unlike the 1973 guard. (Courtesy of CTH.)

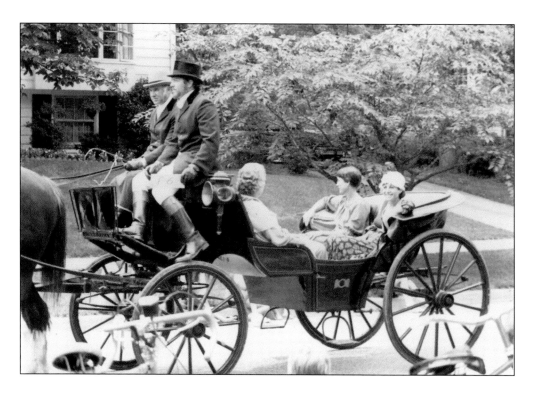

This stately carriage pulled by a team of horses in the Fourth of July parade (date uncertain) was sponsored by Long and Foster Realtors of Crofton. (Both courtesy of MW.)

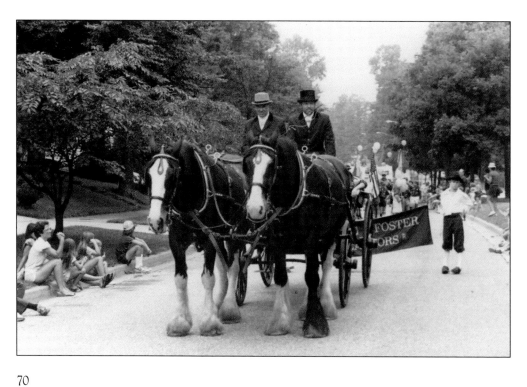

In 1983, the queen of the Independence Day parade rode in a sports car, not an antique auto as her predecessor had in 1973. Note the admiring parents waiting at the side of the road. The photograph below captures the high-stepping pom-pom squad following close behind the queen. (Both courtesy of CTH.)

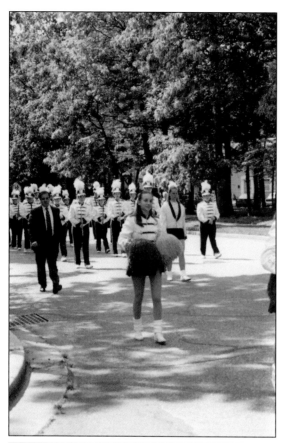

The band marching in this 1995 parade photograph may be the Arundel High School Marching Band. The motorcycles in the photograph below made a splendid racket as they roared along the usually quiet Crofton Parkway. (Both courtesy of CTH.)

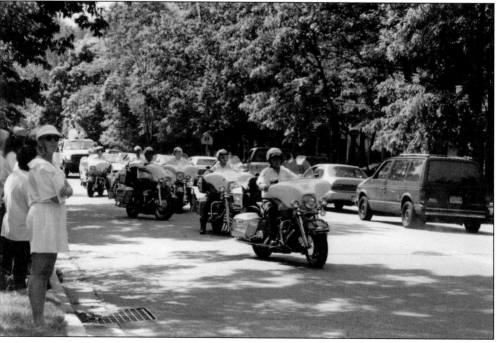

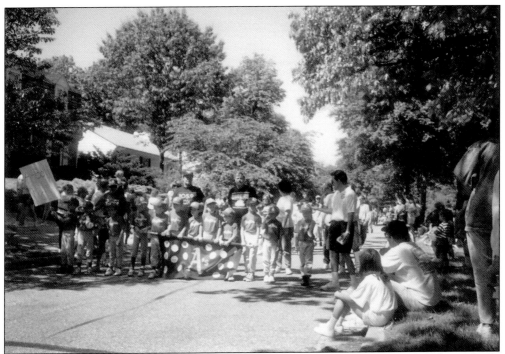

During the 1995 parade, the crack drill formation of the Little League team left the curbside on-lookers speechless. (No applause, please.) (Courtesy of CTH.)

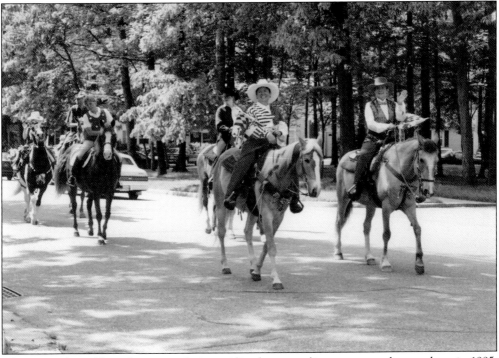

There is nothing like palomino and pinto riding horses to liven up a parade, seen here in 1995. (Courtesy of CTH.)

One of the many wonderful qualities of the Crofton community has always been the involvement of parents and families in the activities and events. This 1983 picture shows moms preparing the children for the parade. (Courtesy of CTH.)

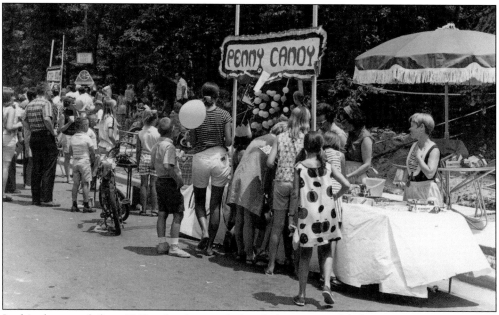

In this photograph from 1969, right along with their kids, moms and dads are enjoying the carnival that followed the Independence Day parade. (Courtesy of Katherine Callahan.)

These pictures from the Fourth of July festivities in the 1970s speak for themselves. These soccer players were out to win this pie-eating contest. (Both courtesy of MW.)

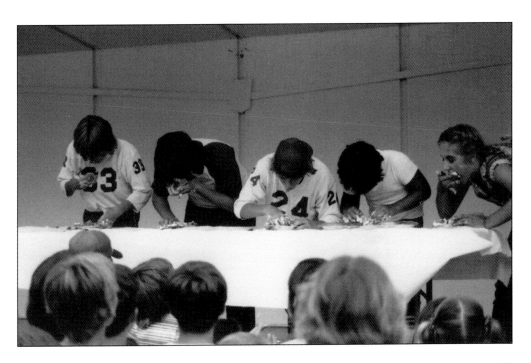

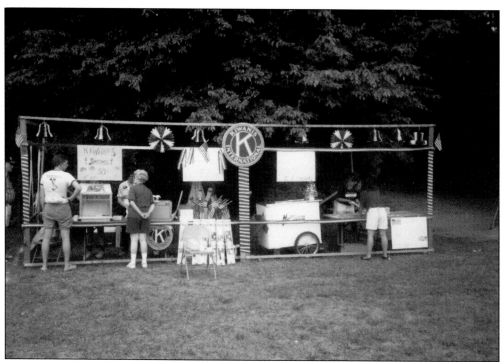

Among the community supporters of the Independence Day carnival, the Kiwanis Club has always been fully involved. Notice the 50¢ snow cones and the free flags. Apparently, in 1973, the Zoo Dip white-elephant booth (below) was not a big draw. But it looks like the food booth next door (above) is trying to encourage some business. (Both courtesy of CTH.)

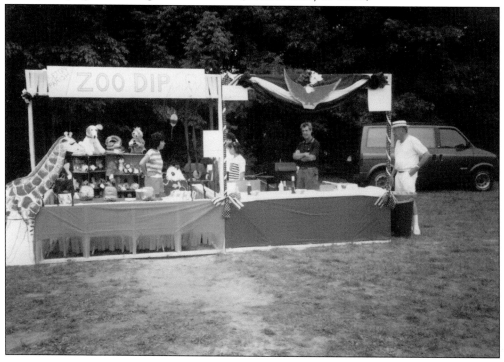

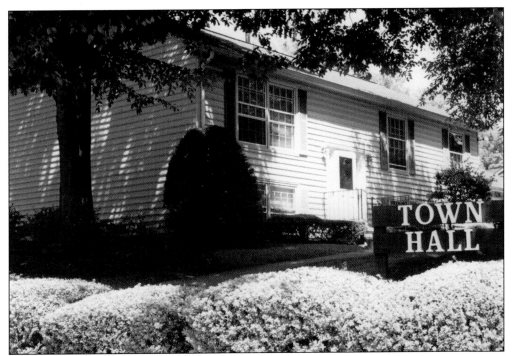

In 1969, the Anne Arundel County Council established the Village of Crofton as a "Special Community Benefit District." Crofton could then begin to levy a small tax or community fee to pay for police protection as well as for maintaining public parks and funding the annual Independence Day parade. At that time, the Crofton Civic Association was established. Twenty years later, in 1989, the Crofton Civic Association joined with other local community groups and associations of the greater Crofton area to form the Greater Crofton Council. Both the civic association and the council are dynamic organizations to this day. (Courtesy of CTH.)

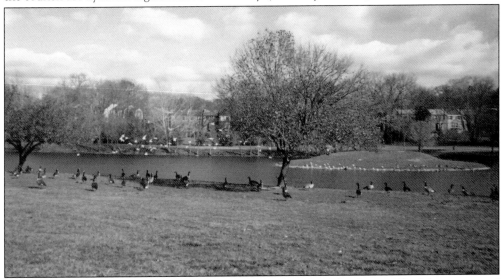

Lake Louise in any season is a charming ingredient of Crofton's landscape. The lake was named after Louise Davis, the wife of Howard Davis, the original vice president of land development for the Crawford Development Company. (Courtesy of CTH.)

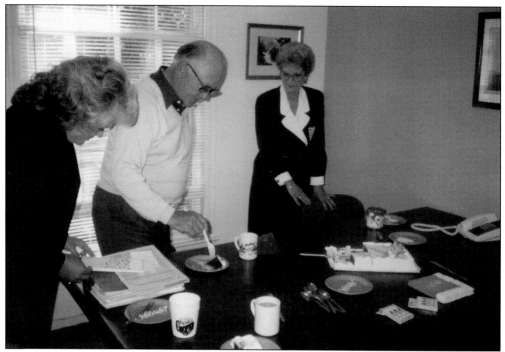

From left to right, office manager Sue Bents, Crofton Civic Association president Ed Dosek, and town manager Barbara Swann were three of Crofton's "movers and shakers" in the 1990s. Sue Bents still manages the town hall. (Courtesy of CTH.)

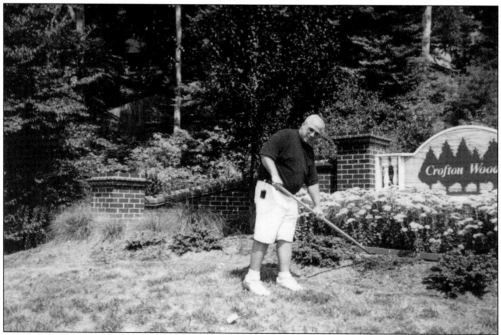

Crofton has always been a "Let's get involved" kind of place. Bob Simpson, captured here sprucing up the flowerbed in front of Crofton Meadows, could always be relied on to lend a hand to make Crofton a better place to live. (Courtesy of CTH.)

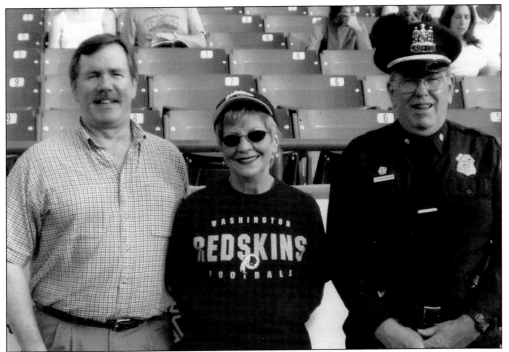
When the Bowie Bay Sox held their 1999 Crofton Day, (from left to right) Larry Schweinsburg, Barbara Swann, and Sgt. Steven Grimaud were there. (Courtesy of CTH.)

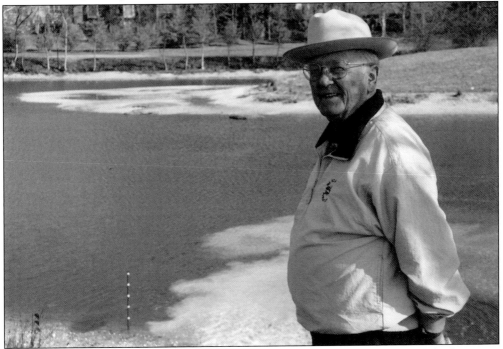
Ed Dosek was the guardian angel for Lake Louise. In 1999, Dosek rescued the lake from near extinction when a severe drought left the lake high and dry. Dosek supervised the delivery of water to refill the lake. (Courtesy of CTH.)

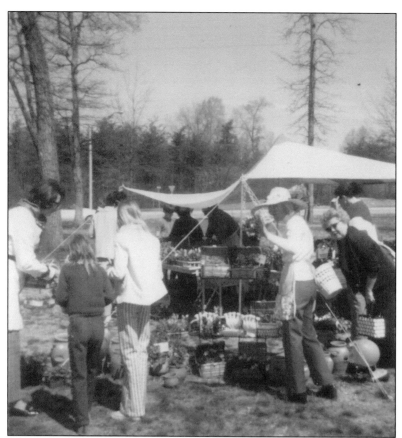

What would Crofton have looked like without the tireless work of its garden club? In 1971 (left), the club held a plant sale to raise money to buy plants for community flowerbeds. And in 1978, the Crofton Garden Club re-landscaped the Village Green. (Both courtesy of the CGC.)

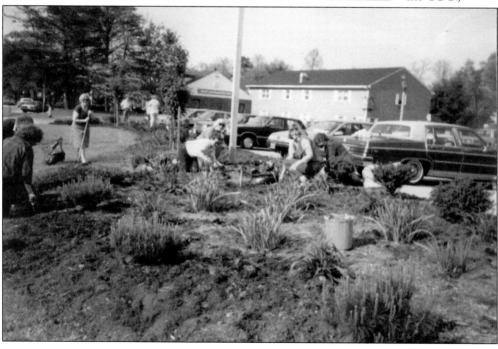

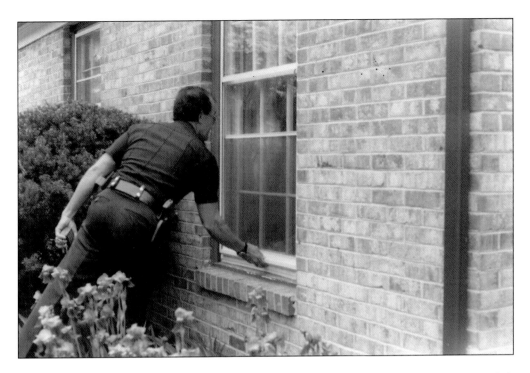

Crofton's police force is dedicated to the community. The above c. 1995 picture captures Cpl. Arturo "Art" Soclolo checking the security of the windows in a local home. Officer Steve Muhl (below) often managed the switchboard and computer systems. (Both courtesy of CTH.)

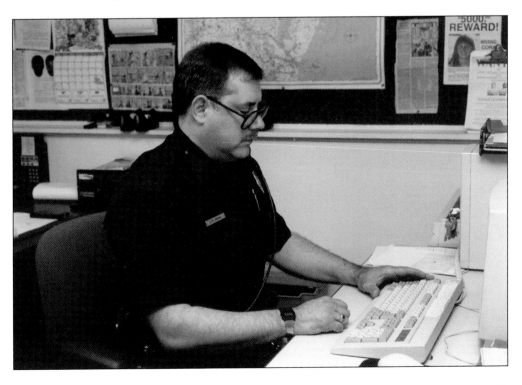

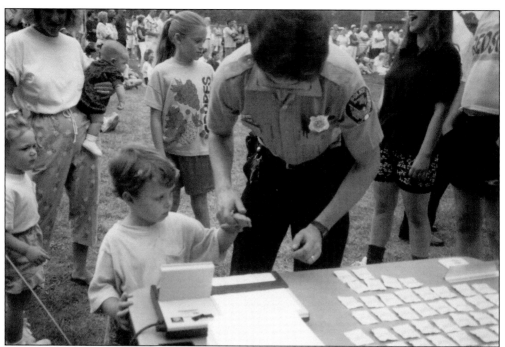

Officer Joel Gordon encouraged children to be fingerprinted during the summer carnival in 1990. (Courtesy of CTH.)

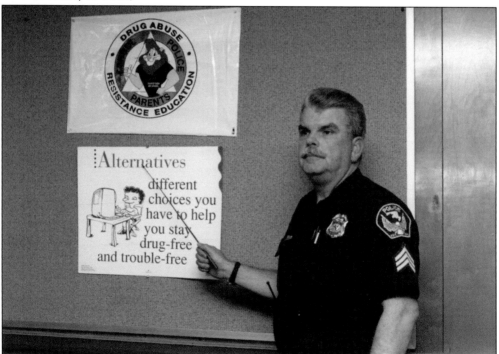

Sgt. John Wortman spearheaded the DARE (Drug Abuse Resistance Education) program in 1995. Here he encourages students at Crofton Woods Elementary to stay drug-free. (Courtesy of CTH.)

Five

SOLIDIFYING THE DREAM
CHURCHES AND SCHOOLS CEMENT THE COMMUNITY

As Crofton has grown in population, it has grown as well in beauty and grace. Small saplings have grown into mighty oaks and maples. The cherry trees planted in the late 1960s are full and magnificent in the springtime. Families and neighborhoods have developed loyalties to schools and athletic teams and clubs and churches as everyone has grown up together. This picture of the First Baptist Church of Crofton captures the mature beauty of Crofton. (Courtesy of MW.)

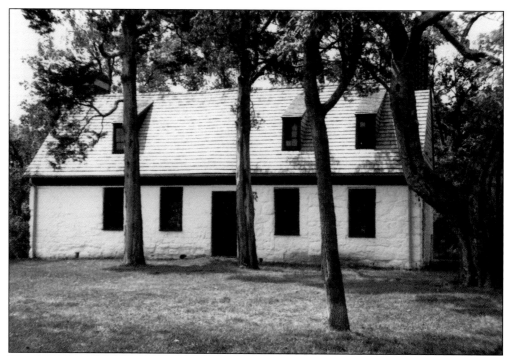

Thanks to the efforts of Herbert Sappington, other local residents, and Anne Arundel historians, the c. 1724 Anne Arundel County Free School has been preserved and restored to its original, simple beauty. (Courtesy of the Linthicum Walks Historical Society.)

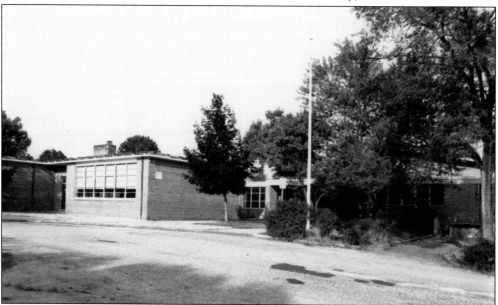

Carver School, built in 1949, replaced two smaller segregated schools for the county's African American students; even traveling to school was aboard segregated buses. After school integration, Carver was first used as a school for the deaf and then as an annex to Crofton Elementary School to ease overcrowding. It remained in use as offices by the county's board of education until 2008. (Courtesy of AAHS.)

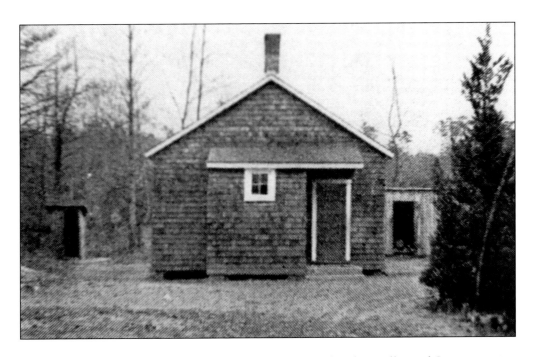

Conaways School (1920–1949) was situated in the once-bustling village of Conaways near what is now the shopping center at the intersection of Routes 3 and 424. The school was segregated, and two teachers taught 60 students in only one classroom. Carver School was built to remedy the overcrowding, and African American students were transferred there. (Both courtesy of AAHS.)

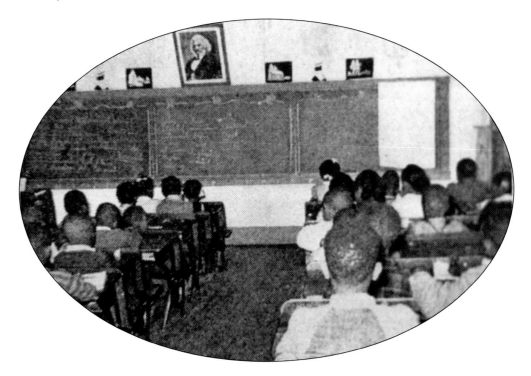

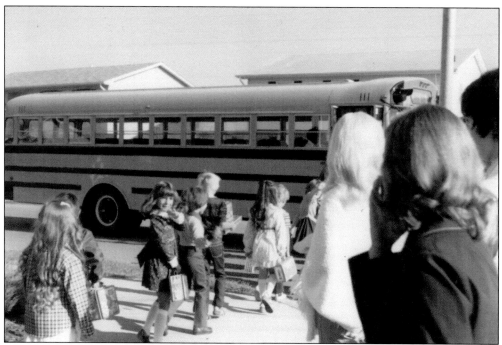

In these two photographs from 1976, children await and board school buses for the first day of classes. Anxious moms watch their darlings head off to elementary school in the above picture. Gina Finelli waves happily at her mom, Carolyn. In the picture below, students from Crofton Meadows wait patiently; they even appear to be happy about setting off to school. (Both courtesy of CF.)

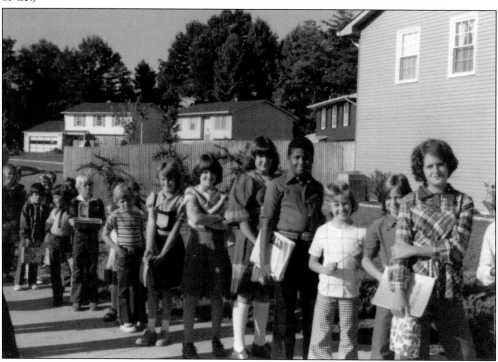

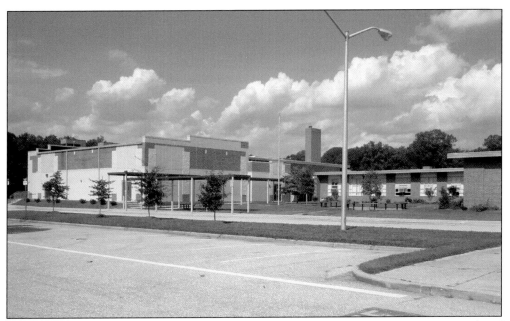
Four elementary schools now serve the greater Crofton area. Crofton Elementary, on Duke of Kent Street, was the first of the community's schools, built in 1968. It serves kindergarten through fifth grade. (Courtesy of MW.)

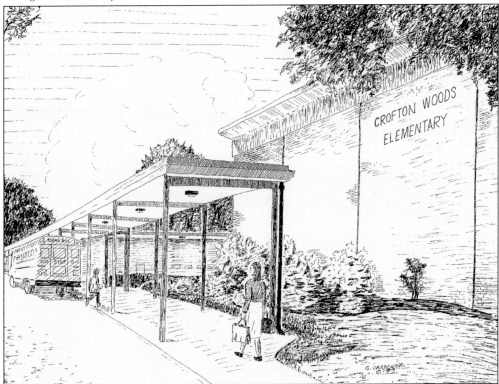
This 1970 pen-and-ink drawing of Crofton Woods Elementary School was done by local artist Glenn Carpenter. The school is located on Urby Drive in Crofton. (Courtesy of Gary Carpenter.)

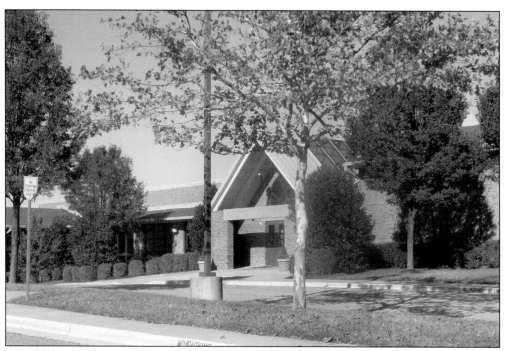

The above 2008 photograph shows Crofton Meadows Elementary School on Tilghman Drive. The picture below, also taken in 2008, is of the newest school in the Crofton community, Nantucket Elementary on Nantucket Drive. (Both courtesy of MW.)

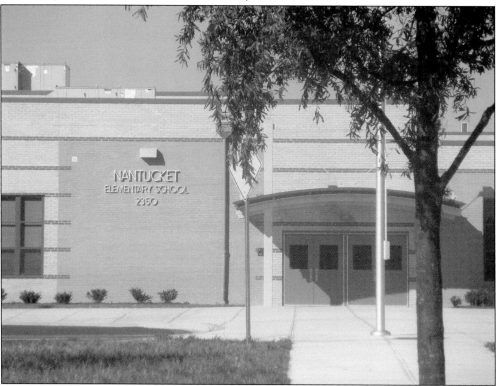

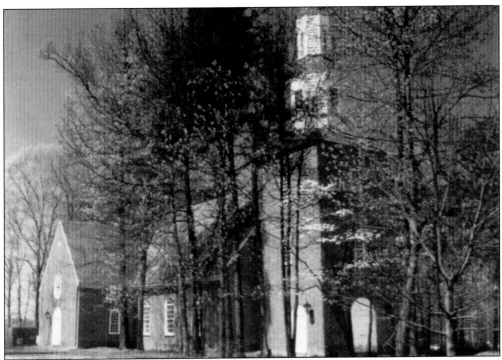

The First Baptist Church on Crofton Parkway was completed in 1971. In keeping with Crofton's Colonial architectural theme, the church was modeled after the Bruton Parish Church in Williamsburg, Virginia. Bruton Parish Church was completed in 1683 and continues to serve its Episcopal congregation to this day. First Baptist Church looks forward to an equally long life of service to Crofton. (Both courtesy of First Baptist Church.)

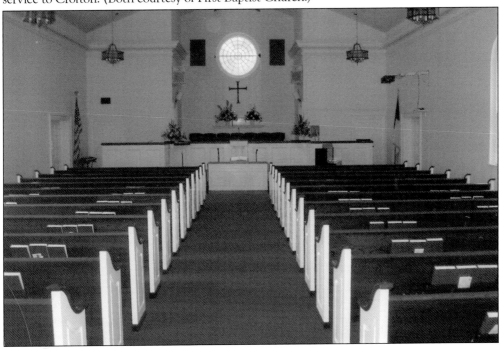

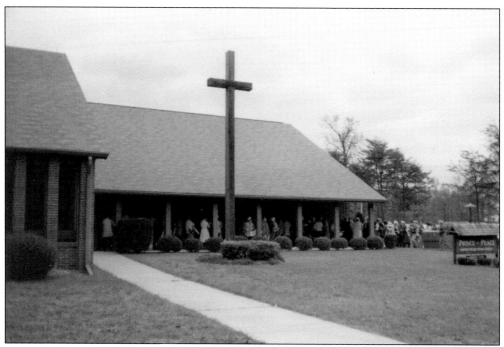

Constructed in 1975, the Prince of Peace Presbyterian Church and its fellowship hall are home to an active congregation. The crucifix that towers over the church is a landmark on Crofton Parkway. (Above courtesy of Katherine Callahan; below courtesy of MW.)

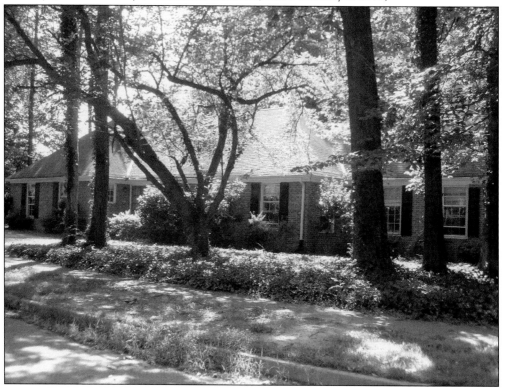

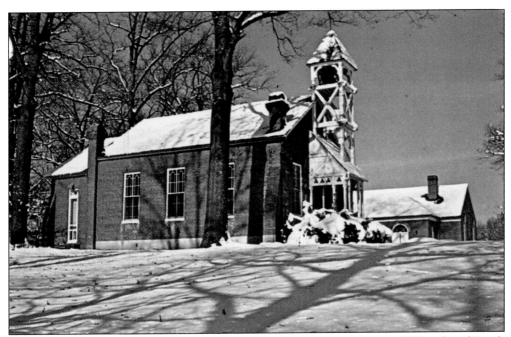

At the outer reaches of the greater Crofton community, St. Stephens Episcopal Church and Parish Hall, located on St. Stephens Church Road, dates to 1838. (Both courtesy of AAHS.)

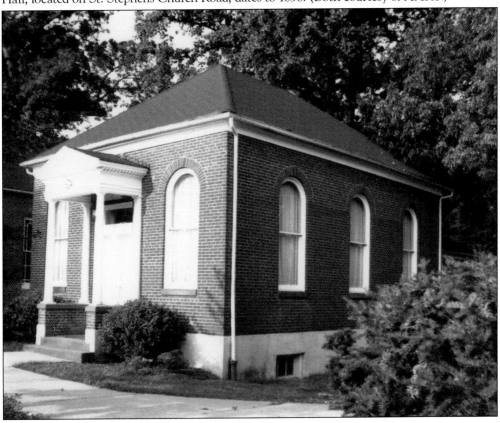

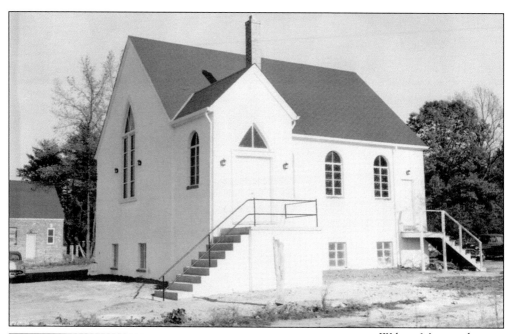

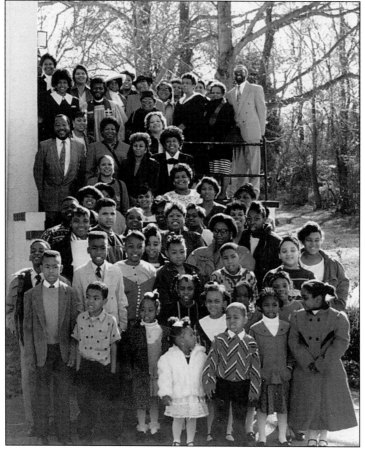

Wilson Memorial Church established its congregation around 1900. The photograph at left captured the congregation in 1950 celebrating Wilson Memorial's golden anniversary. (Both courtesy of Wilson Memorial Church.)

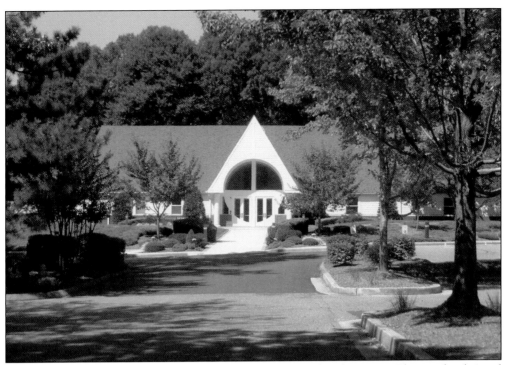

Established in 1975, St. Elizabeth Seton Parish dedicated its church in 1981. The parish is located just east of Route 424. If someone has been in Crofton and paused for a moment to listen to the ringing bells at noon or 6:00 p.m., those are the four bronze bells of Seton Parish. The lower picture shows the Seton Parish Youth Choir rehearsing in 1988. (Above courtesy of MW; below courtesy of CF.)

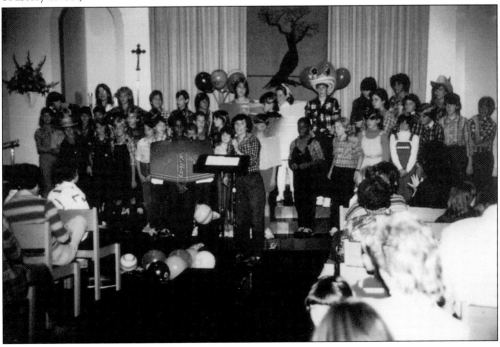

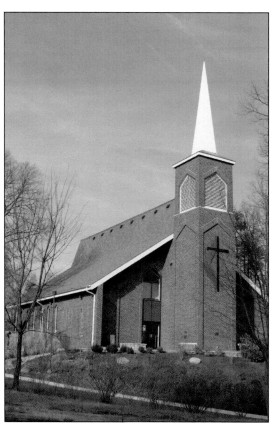

Located on Riedel Road, Community United Methodist Church has a membership of approximately 1,000. (Courtesy of Community United Methodist Church.)

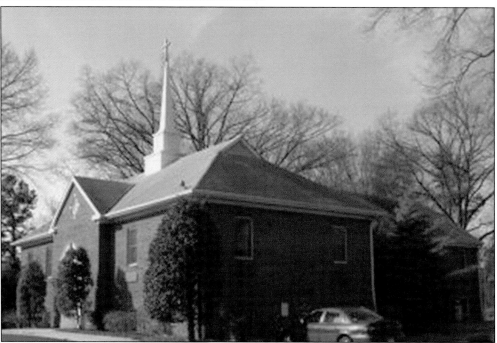

St. Paul's Lutheran Church is located on Defense Highway. (Courtesy of CF.)

Six

LIVING THE AMERICAN DREAM

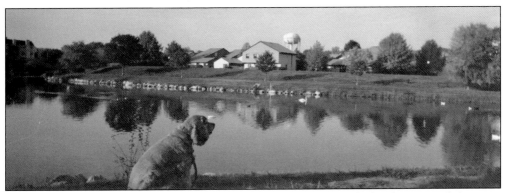

Hamilton Crawford dreamed of developing a pastoral community with the elegance and character of Colonial American traditions. Looking at Crofton as it grows into the 21st century, that dream seems to be realized. Crofton and its surrounding communities maintain the air of quiet dignity. Couples walk their children and pets along the parkway and through the parks. The annual Independence Day festivities remain the events that anchor the community. Social clubs and athletic teams still flourish. Life goes on; families leave and others arrive. And in all the ebb and flow of life, there is nothing lovelier than pausing to watch the geese and feel the breeze across Crofton Meadows Lake. (Courtesy of CF.)

And if a walk around one of Crofton's lovely lakes is not enough, there is always the playground at Swann Park. The park honors Tom and Barbara Swann, civic leaders in Crofton village. Barbara Swann was town manager for many years. Tom Swann was honored as the 1973 Citizen of the Year for his work with teens, establishing a teen club in Crofton. (Courtesy of MW.)

Crofton's town hall sits modestly on Crofton Parkway. The Crofton town manager and the police department are housed there. In 1973, the developers donated the sales office to the community for its town hall. (Courtesy of MW.)

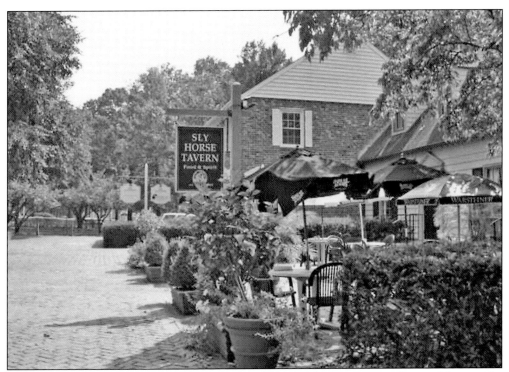

The Village Green, with its small businesses, still serves the community. Pictured here is the Sly Fox Tavern. Designed after the Reynolds Tavern in Williamsburg, the Sly Fox was initially the Village Green Tavern. The post office was also situated on the Village Green until the construction, during the late 1990s, of the new post office in what was once Walch's Grove. (Courtesy of MW.)

Pictured here is the Crofton Public Library on Riedel Road, a fitting location since the road recalls one of the oldest farms and families in the area that became Crofton. This handsome facility replaced a smaller library that was located in the Crofton Center. (Courtesy of MW.)

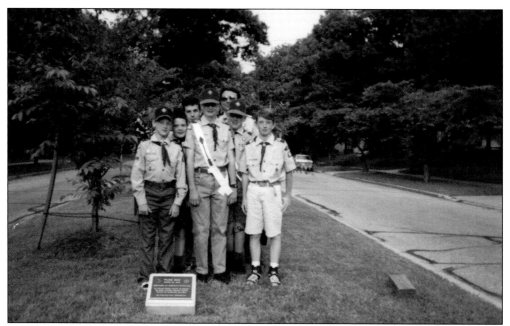

The foundation of Crofton's growth and stability began as and remains the family. Every plan and program has evolved with children and families in mind. In 1994, Crofton's Boy Scout troop planted and dedicated trees to the community's World War II veterans along the parkway. (Courtesy of CTH.)

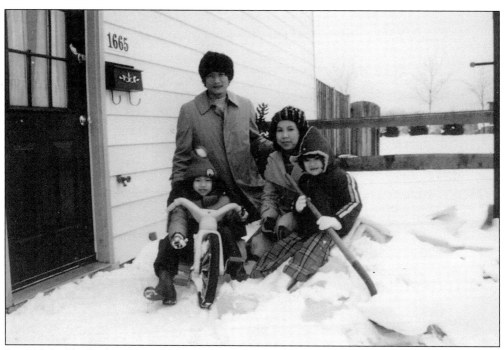

In 1985, St. Elizabeth Seton Parish and the Crofton community sponsored the Outhit Vilaythong family. After the Vietnam War, they fled Laos for America and a new beginning. The family still lives in Crofton and remains active in the parish. (Courtesy of the CGC.)

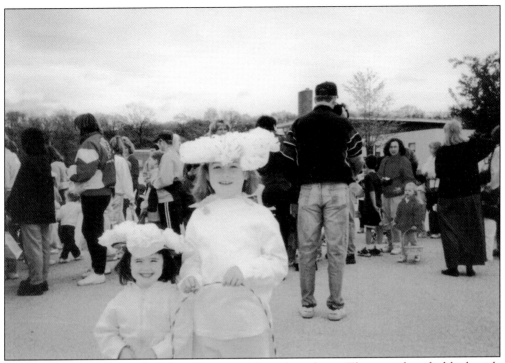
Springtime in Crofton included an Easter parade and egg hunt. These unidentified little girls proudly display their Easter bonnets in 1994. (Courtesy of CTH.)

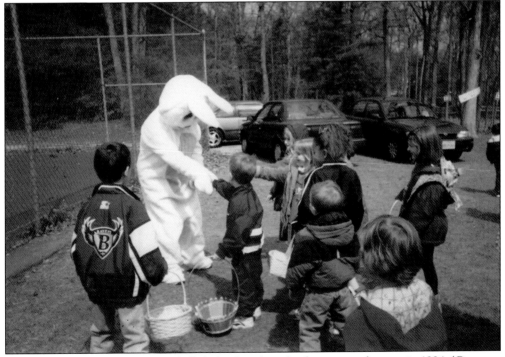
The Easter Bunny (Karen VanSickel) shakes hands with admiring egg hunters in 1994. (Courtesy of CTH.)

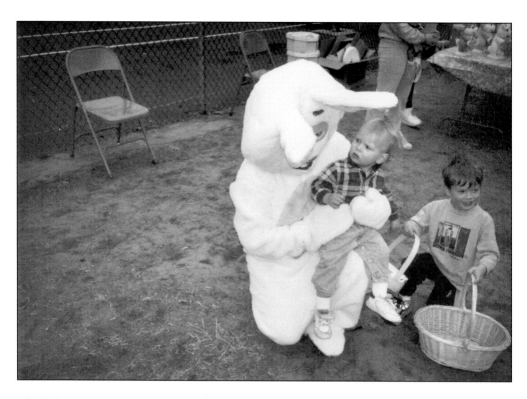

The little guy in the picture above seems a bit unsure of the Easter Bunny, but big brother is nearby. In the picture below, everyone hunts for eggs on an early spring day. (Both courtesy of CTH.)

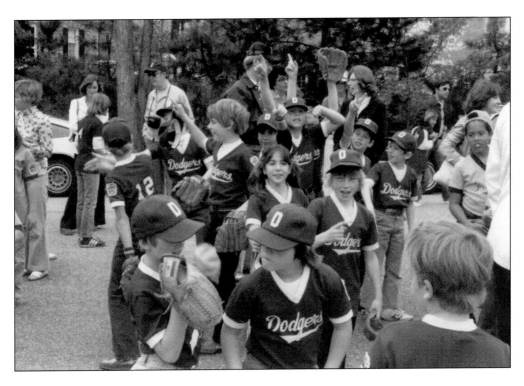

The Crofton Dodgers' 1979 Little League game looks pretty exciting. Michael Finelli (below, in 1981) may have a career in the big leagues with that swing. (Both courtesy of CF.)

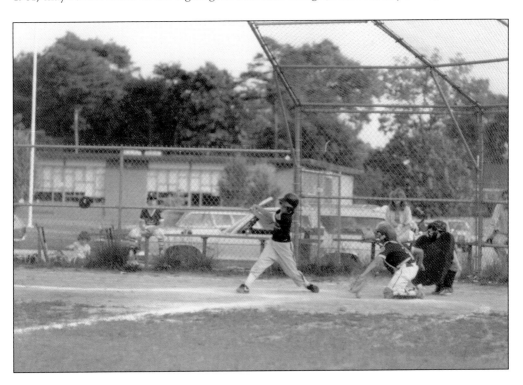

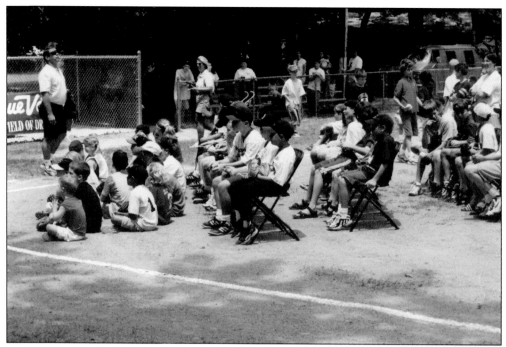

The coach has some specific advice for his attentive baseball team in 1998. Notice the parents closely following the coach's lecture. Crofton parents get involved; they are behind their children's activities 100 percent. (Courtesy of CTH.)

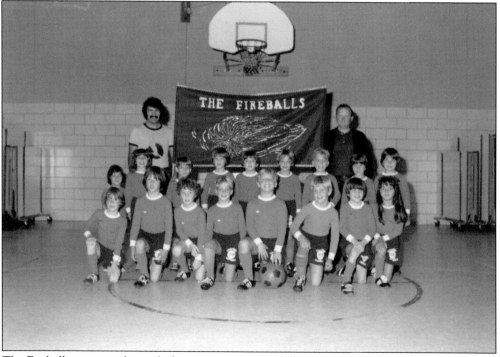

The Fireballs appear to be ready for action in this 1976 photograph of the soccer team. Coaches were, from left to right, Dominic Finelli and John Molster. (Courtesy of CF.)

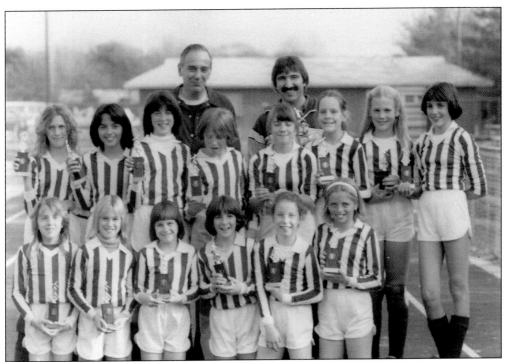
The girls' soccer team proudly displays their trophies in this 1980 photograph. Coaches Jack Williams (left) and Dominic Finelli (right) stand proudly behind their girls. (Courtesy of CF.)

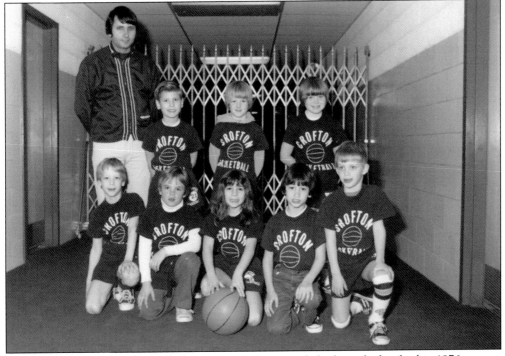
One of Crofton's many basketball teams and their coach look ready for the big 1976 season. (Courtesy of CF.)

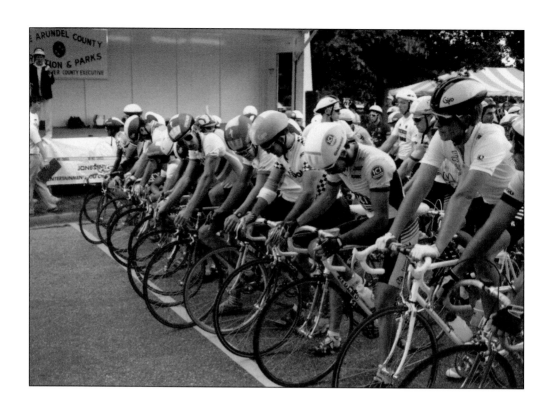

Crofton hosted a popular bike race in 1995. (Both courtesy of Katherine Callahan.)

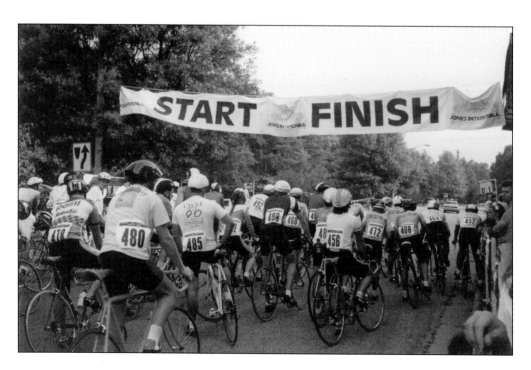

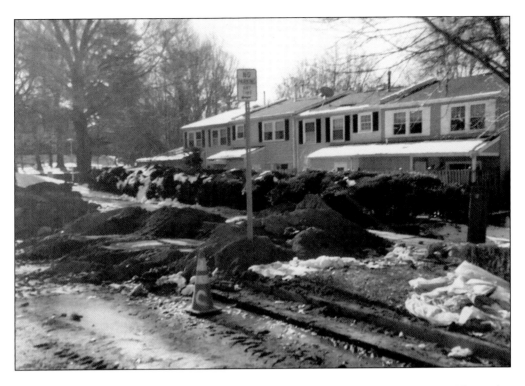

Perhaps in preparation for the big bike race, or just as part of regular maintenance, 1995 was also the year of major street repairs in Crofton. (Both courtesy of CTH.)

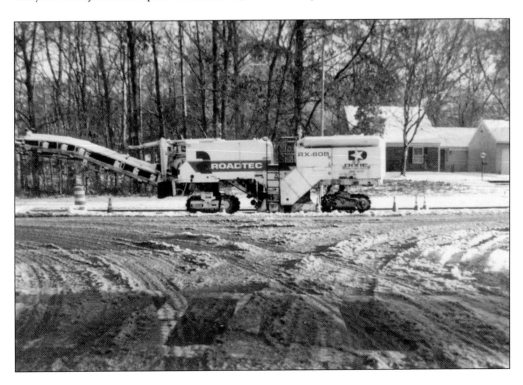

Crofton Country Club is at the heart of Crofton, literally. The golf course was part of the original design for the development, and many of Crofton's first-built houses are situated along the greens. (Both courtesy of MW.)

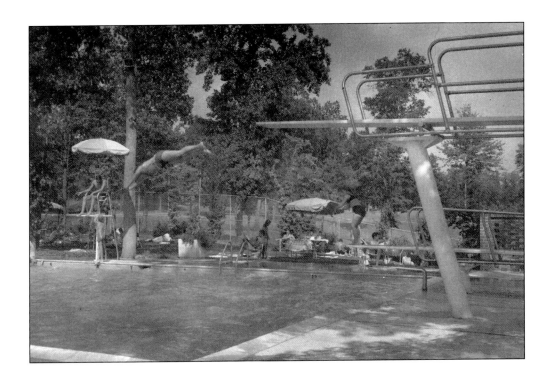

These 1966 photographs of the country club pool remind us of the club's contribution to family life in Crofton and the club's staying power. (Both courtesy of John Pritzlaff.)

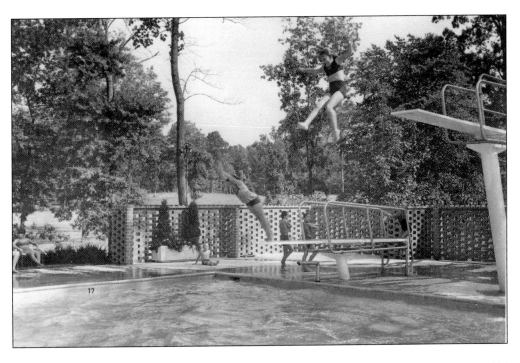

These two photographs, taken in 1995 (above) and 2008, capture the handsome, mature trees that are part of Crofton's heritage. Hamilton Crawford was careful to protect these magnificent stands of trees when he developed Crofton, and the community has protected the trees and continued to plant additional specimens. (Above courtesy of CTH; below courtesy of MW.)

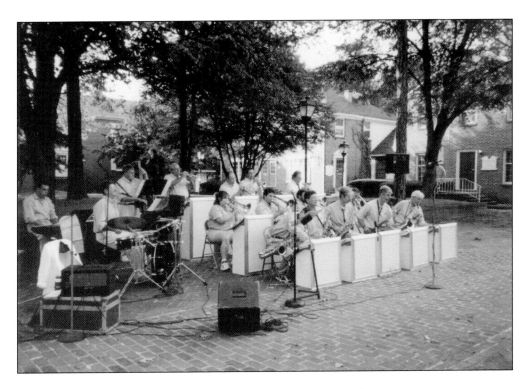

Crofton's tradition of family activities continues, from spring egg hunts to summer concerts on the Village Green. This concert in 2000 drew quite an appreciative audience. (Both courtesy of CTH.)

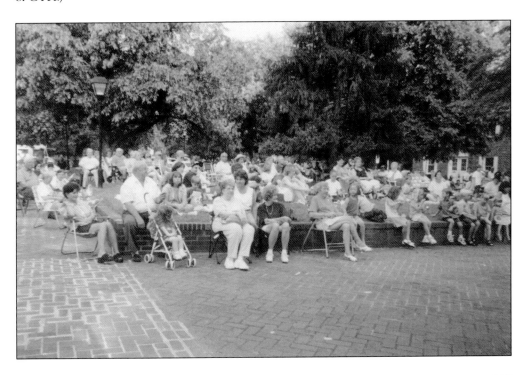

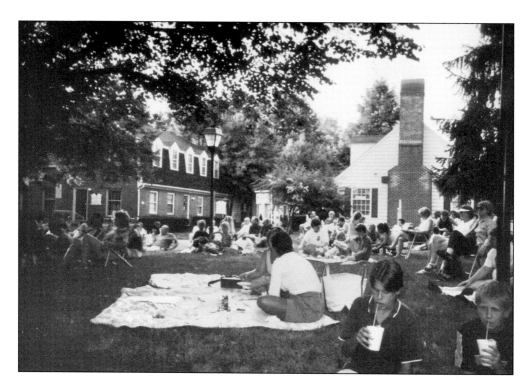

Picnicking on the Village Green on a warm summer's evening was a great way to enjoy the Sweet Adelines, shown below. Crofton's community spirit is founded on just such gatherings. (Both courtesy of CTH.)

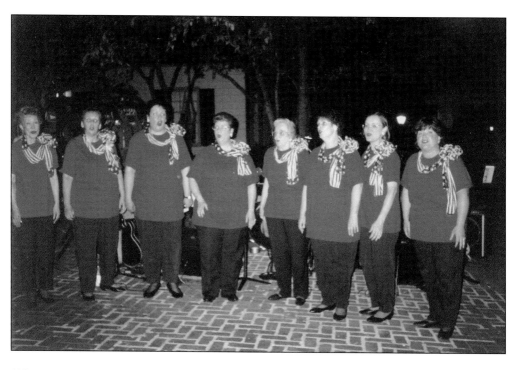

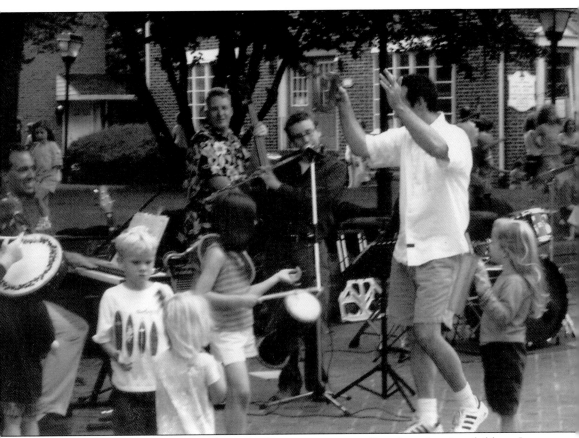

The "Pied Piper" seems to have enchanted a few grown-ups as well as these dancing children. It looks like a great time was had by all. (Courtesy of CTH.)

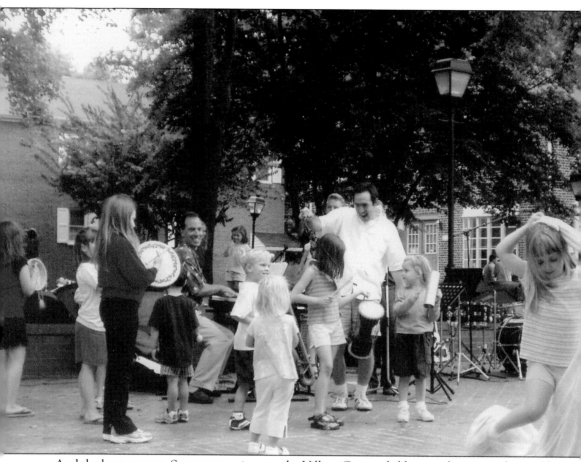
And the beat goes on. Summer evenings on the Village Green, children, and music—who could ask for more? (Courtesy of CTH.)

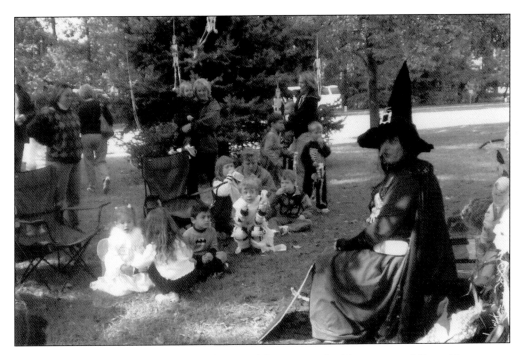

After the springtime Easter egg hunt, there are bike races and athletic teams, followed by summer swimming, golf, and concerts. Crofton brings the community together in the fall for Halloween festivities. The above picture, taken in 2003, captures a group of little gremlins dressed for Halloween and listening to the wily witch's scary tales. The pumpkins look pretty happy about their chances for winning a prize in the 2004 pumpkin-carving competition (below). (Both courtesy of CTH.)

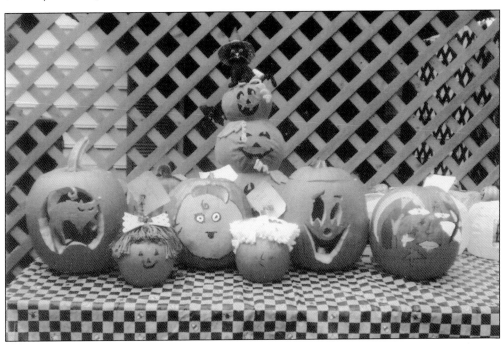

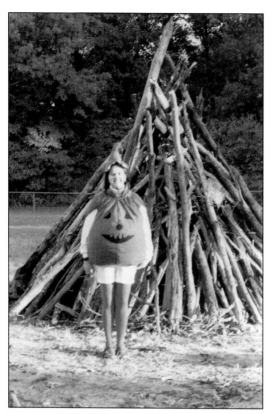

This 1995 "Miss Pumpkin" seems happy with her costume and ready for the evening's bonfire. And William Strasser, Master Pumpkin 2003, is ready for the Halloween costume parade. (Both courtesy of CTH.)

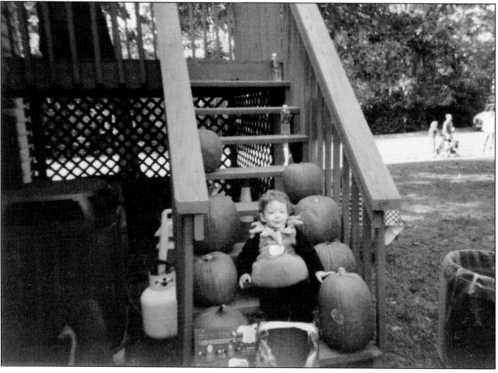

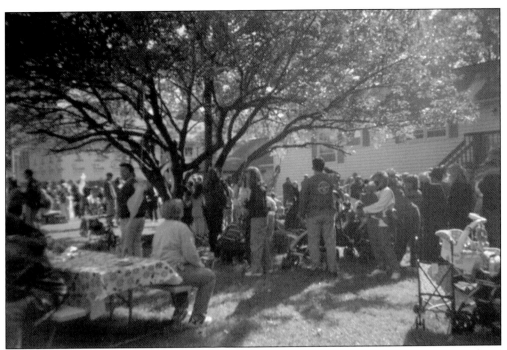

Families gather in the park to await the judges' decisions on the winning costumes and pumpkins. The excitement is combined with good cheer on this fall evening. And here are the judges (below) hard at work selecting the winning pumpkins in the 2001 competition. One can just see the hot chocolate booth in the background run by the industrious Girl Scouts. (Both courtesy of CTH.)

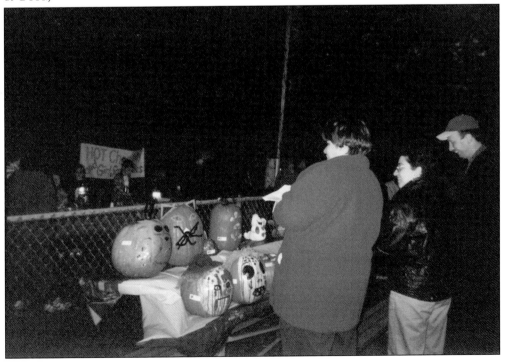

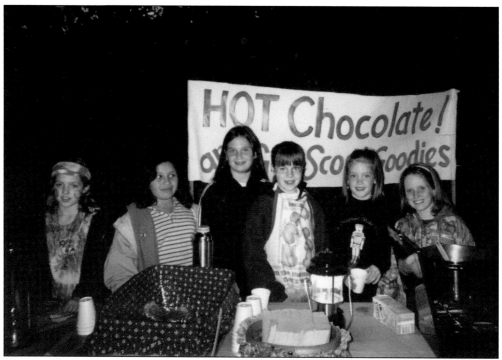
Here is a closer look at the Girl Scouts on duty at the Halloween hot chocolate booth in 2003. It looks like they were all enjoying the event. (Courtesy of CTH.)

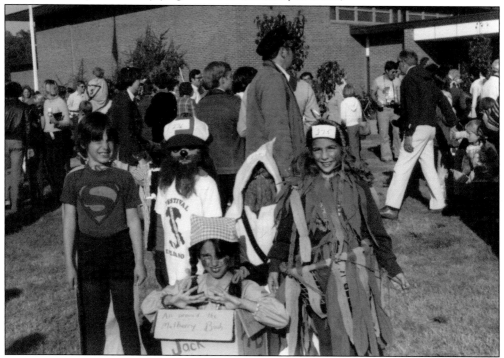
Another group of cleverly costumed revelers gather for this 1978 photograph at the conclusion of Crofton's costume parade. (Courtesy of CF.)

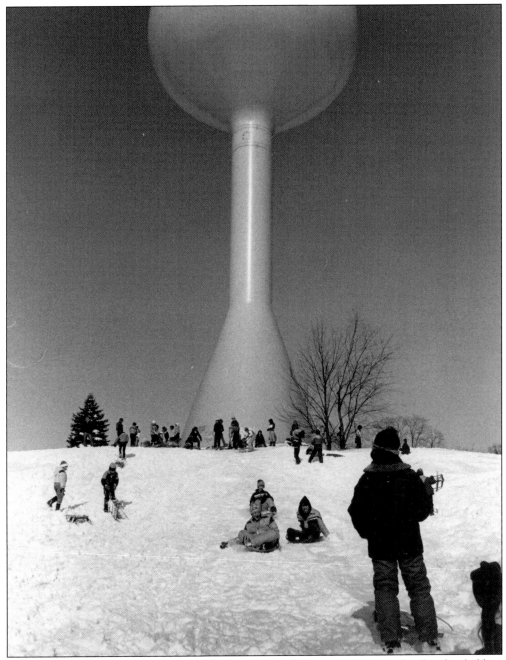
As fall turns to winter in 1999, a rare blanket of snow brings out Crofton's families for sledding and tobogganing on the hill near the Crofton Meadows water tower. (Courtesy of CTH.)

Danny Gerkewiez, where are you? Danny made the most of a light dusting of snow in 1964 to do a bit of sledding. (Courtesy of CTH.)

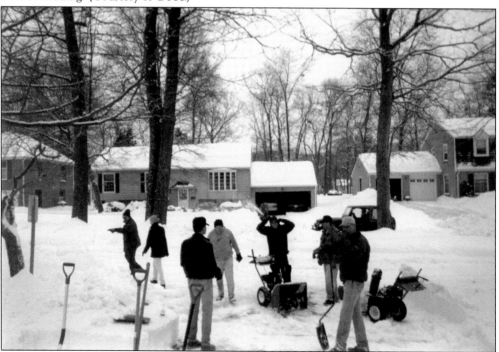

When snowstorms do come, Crofton's residents come out to lend a hand. After the "big storm" of 2004, the neighbors and police officers worked together to clear the drive and sidewalk at the town hall/police station. (Courtesy of CTH.)

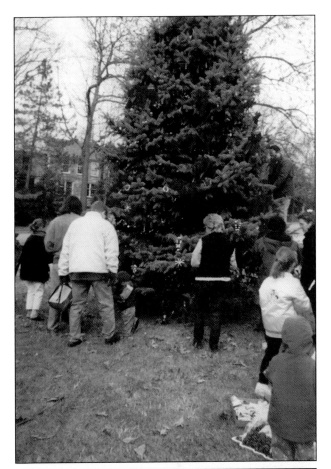

The holidays are celebrated with decorations on the official Crofton evergreen, planted by the Crofton Garden Club. At right, in 2002, volunteers gather to decorate the tree with lights and ornaments. The wrought-iron gates are also trimmed with wreaths and garlands by the Garden Club, below in 2008. (Right courtesy of CTH; below courtesy of MW.)

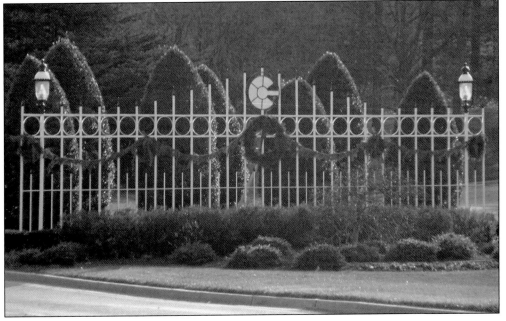

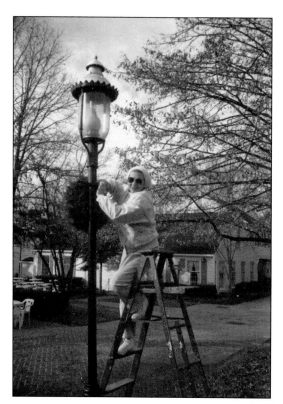

A Garden Club volunteer trims the lampposts on the Village Green in 1984. In the 1986 photograph below, Gail Brooks gathers pinecone wreathes for decorating. (Both courtesy of the CGC.)

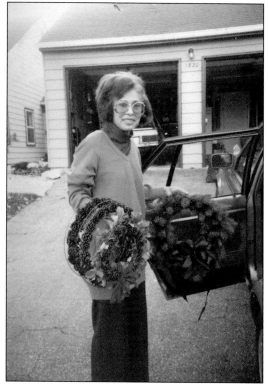

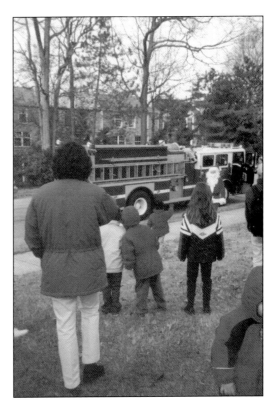

The holiday festivities cannot get truly underway until Santa arrives. Here he comes, alighting from the big, red fire truck in this 1991 photograph. In front of the decorated Crofton evergreen, Santa has a chat with one of his admirers. (Both courtesy of CTH.)

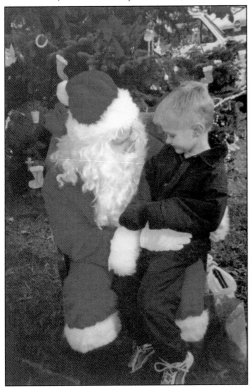

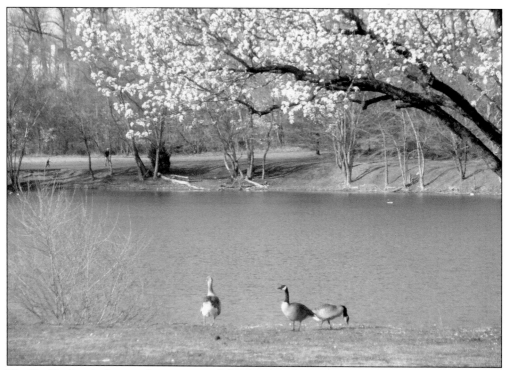

Finally, Crofton is the people, nature, and the dreams of Hamilton Crawford and countless men, women, and children who have called Crofton home. Lake Louise is bordered with cherry blossoms and the quiet elegance of an egret on the lake. (Both courtesy of MW.)

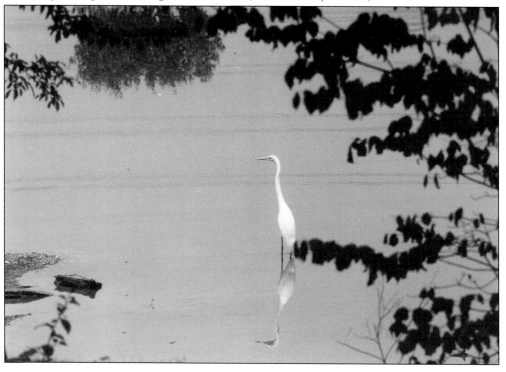

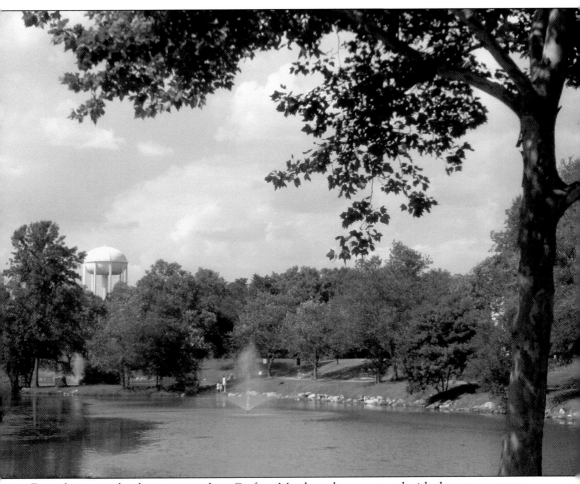
Even the newer developments, such as Crofton Meadows, have matured with the same concern for family and respect for the beauty of the natural environment—attested to by this view of Crofton Meadows Pond. (Courtesy of MW.)

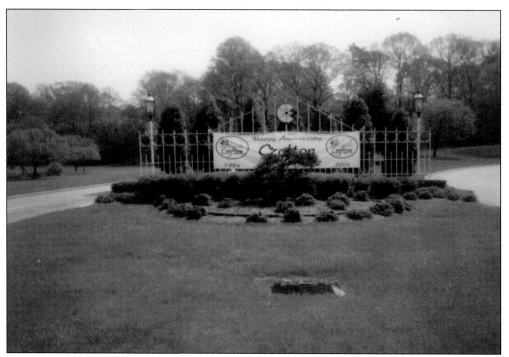

The gates of Crofton stand open, welcoming new residents and old. The banner in the upper photograph announces the 40th anniversary of Crofton, celebrated in 2004. (Above courtesy of CTH; below courtesy of MW.)

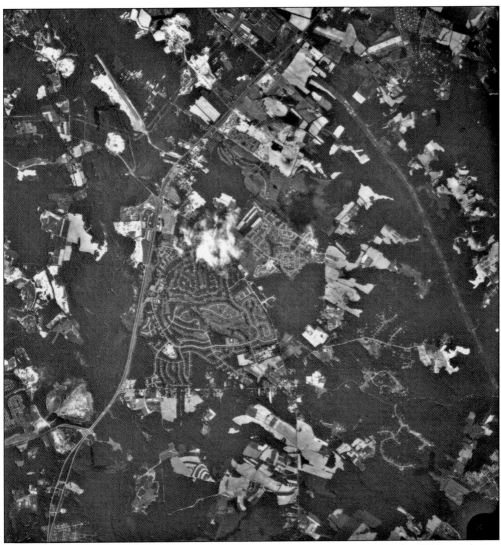

This 1980 aerial view of the Crofton triangle is an interesting contrast with the 1943 aerial view from chapter one. A rich blanket of trees and greenery remains; however, more rooftops and streets, driveways, and parking lots are apparent. More families share in Hamilton Crawford's dream of Crofton. (Courtesy of AAHS.)

Finally, the mature trees that shade the community, the curving parkway and streets, the lake and ponds, and the parks and school yards are in the care and under the protection of the citizens of Crofton. The first 45 years of Crofton's existence have brought prosperity and the nurturing of

the simple joys of life, which are captured in these photographs. What the future brings is in the hands of current and future residents of Crofton. (Courtesy of Carolyn Finelli.)

DISCOVER THOUSANDS OF LOCAL HISTORY BOOKS FEATURING MILLIONS OF VINTAGE IMAGES

Arcadia Publishing, the leading local history publisher in the United States, is committed to making history accessible and meaningful through publishing books that celebrate and preserve the heritage of America's people and places.

Find more books like this at
www.arcadiapublishing.com

Search for your hometown history, your old stomping grounds, and even your favorite sports team.

Consistent with our mission to preserve history on a local level, this book was printed in South Carolina on American-made paper and manufactured entirely in the United States. Products carrying the accredited Forest Stewardship Council (FSC) label are printed on 100 percent FSC-certified paper.